For The Bills,

WITH BEST WISHES AND
HOPE FOR MORE PEACE
AND GRACE IN THIS
WORLD OF OURS,

Jock REYNOLDS
8/27/03

After 9/11

Photographs by Nathan Lyons

With an introduction by Marvin Bell
and afterwords by Richard Benson and Jock Reynolds

Yale University Art Gallery
Distributed by Yale University Press,
New Haven and London

"FLAGS CLEANED FREE"

Marvin Bell
Iowa City, 2002

Where wind attempts to shred a flag,
where death is no cartoon, but a mythic Superman
stands breasting the tide
of blood and more blood to come,
where a scowling Uncle Sam points,
and a flag weaves a field of faces,
where flags describe each horizon and some
aim downward into the molten core of Earth,
where graffiti tag blossoms into a banner with a story,
where street life has become one long bulletin board
stretching the limits of hope,
and where a symbol soaked in the blood
of a universal cherry sea
staggers a mournful heart,

2

here where a soiled flag gains sanctity,
in the emblem that everyone thought they knew
one may see the stars wrinkle as if to weep,
and the horizontal bars waver,
and one may feel the wind die and the flag hang
without snapping, so tired
of having been all things to all people,
waiting in the window,
defiant in battle, funereal at gravesite,
here

where cloth now reflects, or seems to,
mirroring the windows, the smoke, the debris,
the residue, the grief,
the sky-high towers and disembodied faces,
here reflections flood the street
in an air heavy with streaming pennants,
in a light that barely escapes the sky,
and because of this one hears
in the whistling a hint of voices in the wind,
the children calling from afar,
borne by the unspeakable
and cloth mute from the inescapable burden
and gravity.

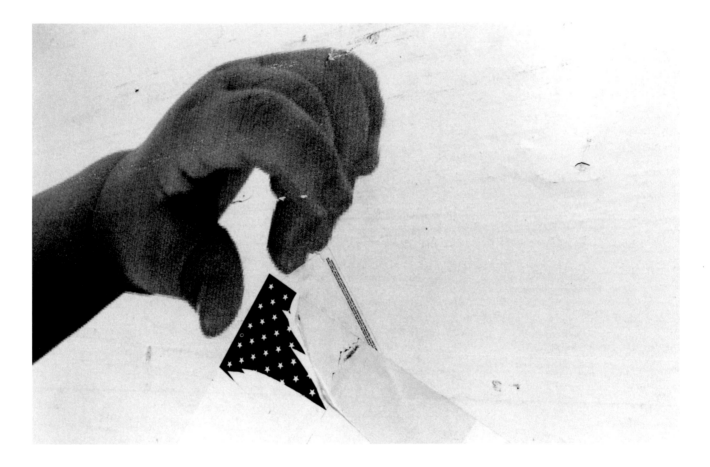

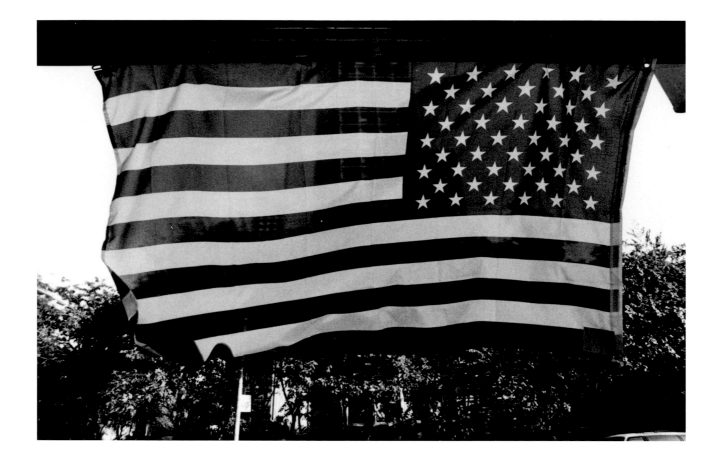

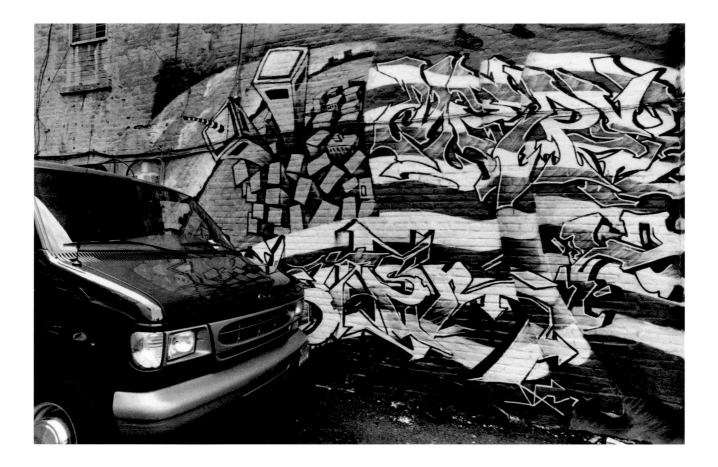

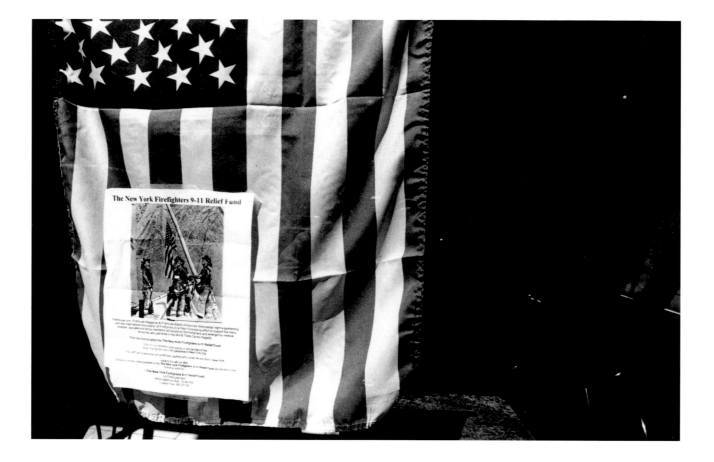

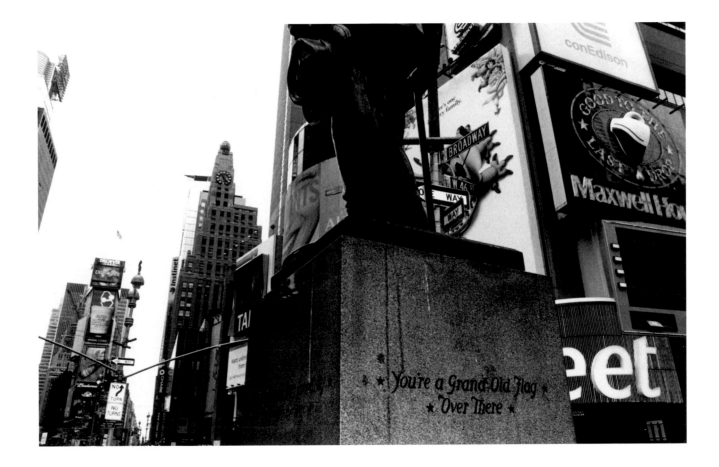

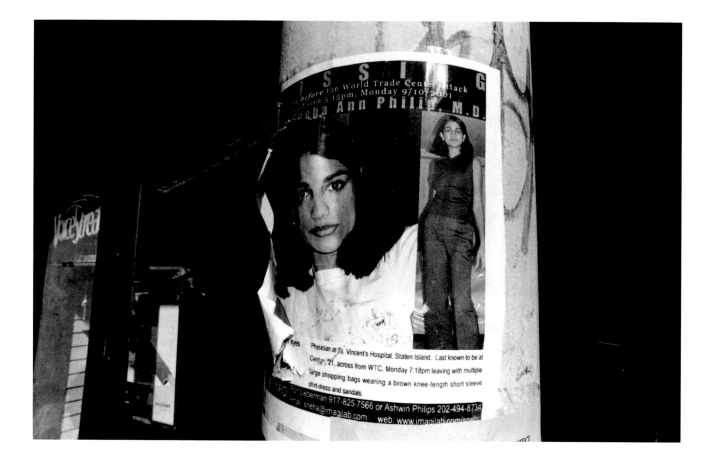

10

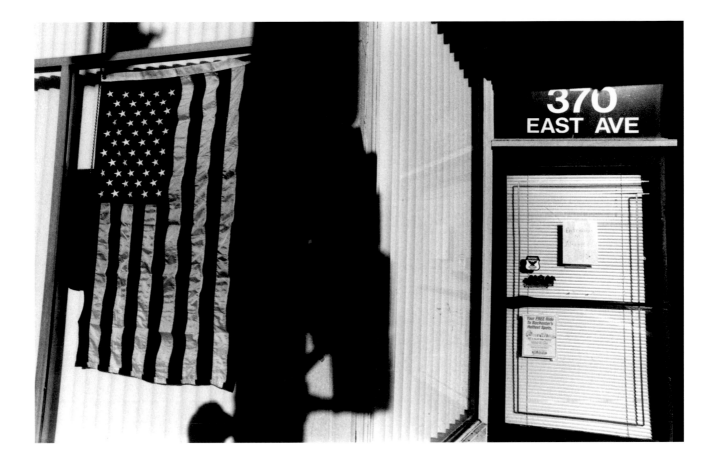

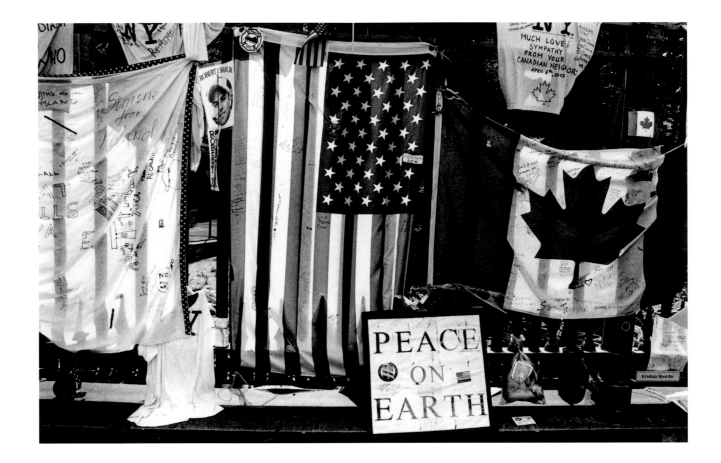

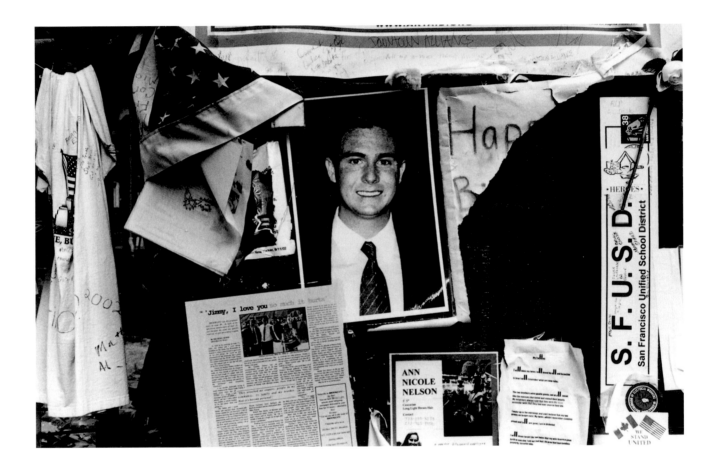

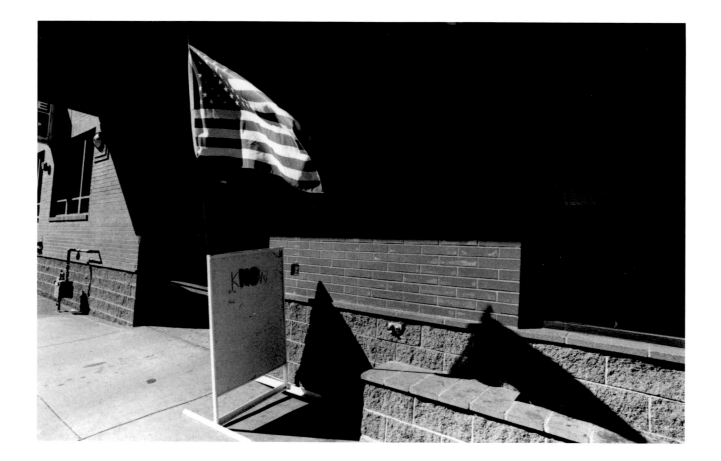

14

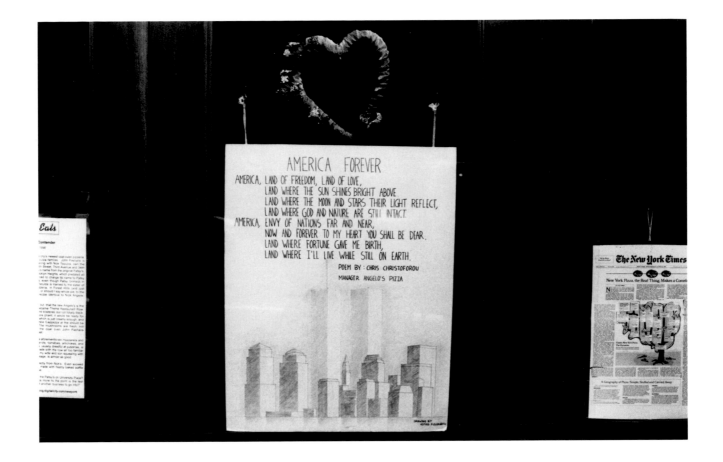

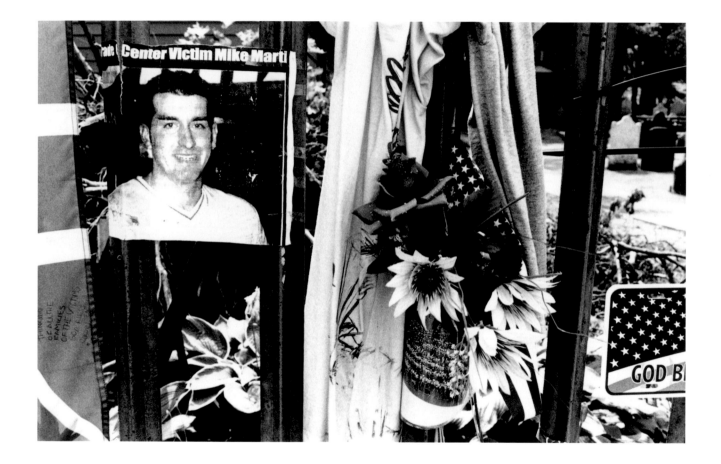

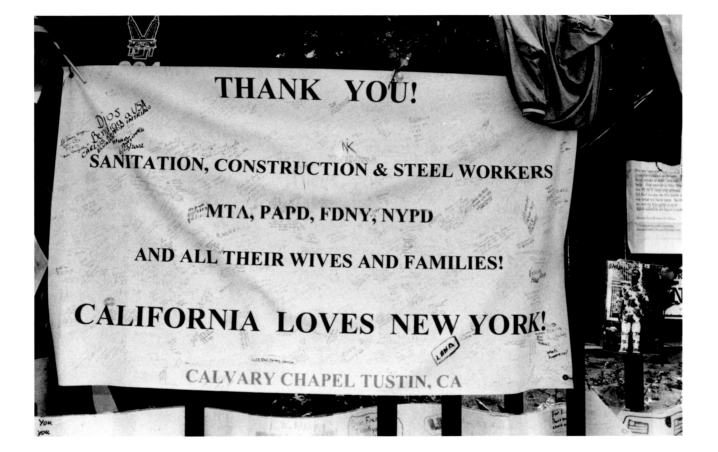

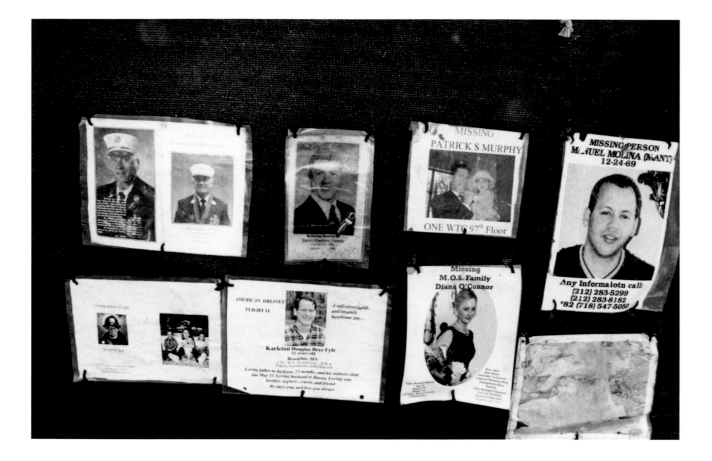

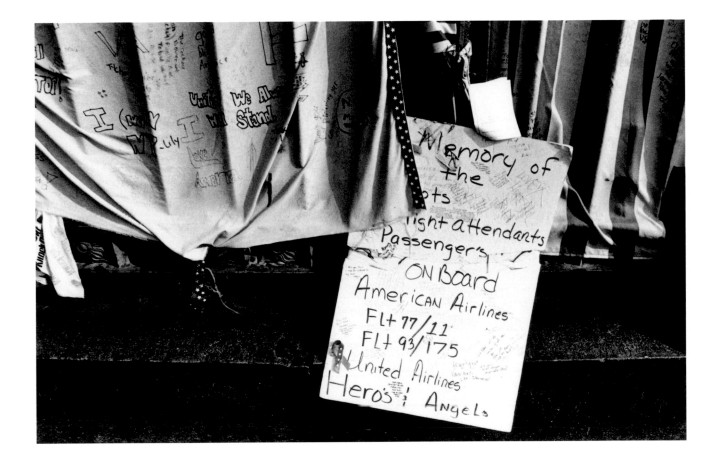

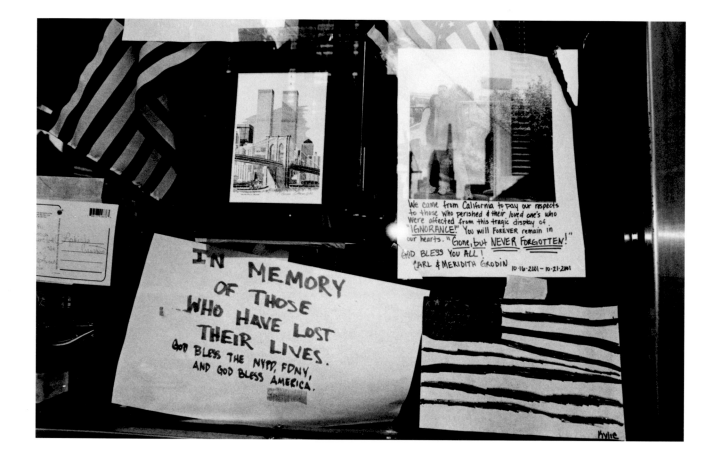

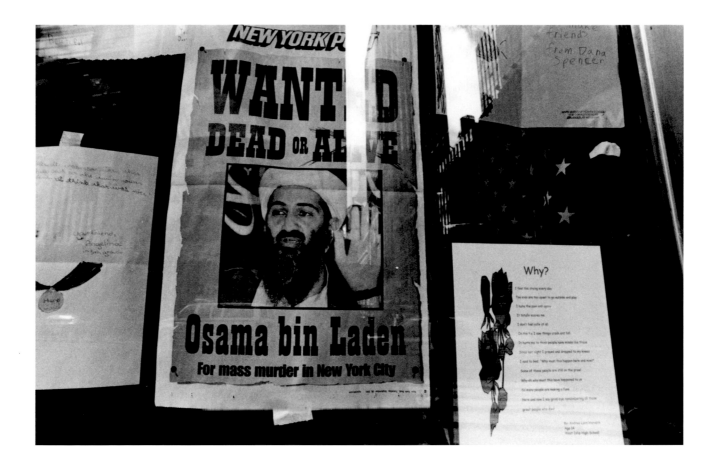

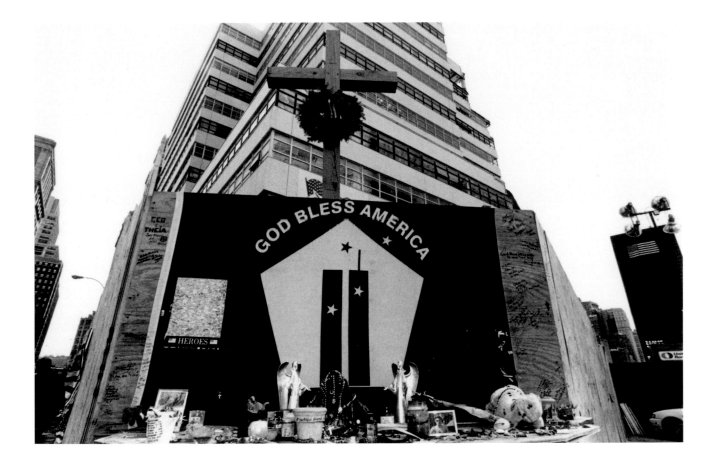

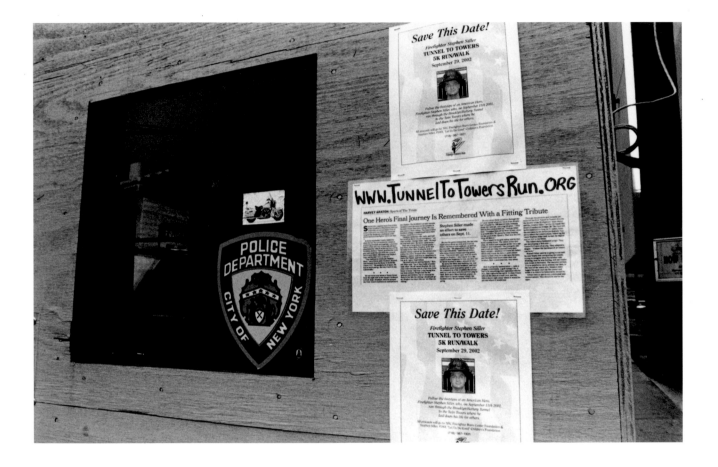

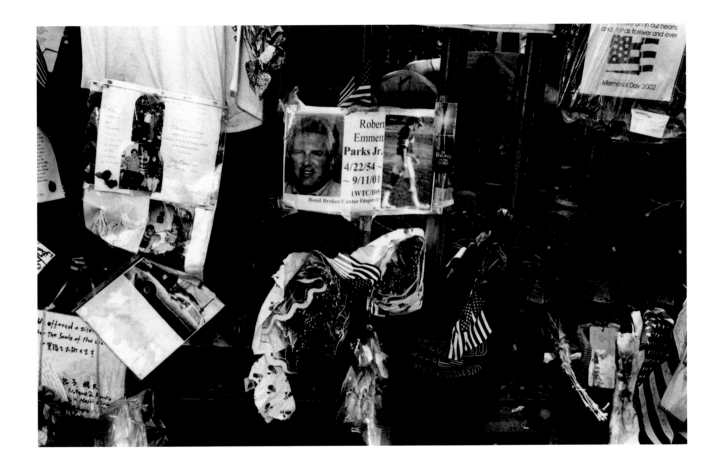

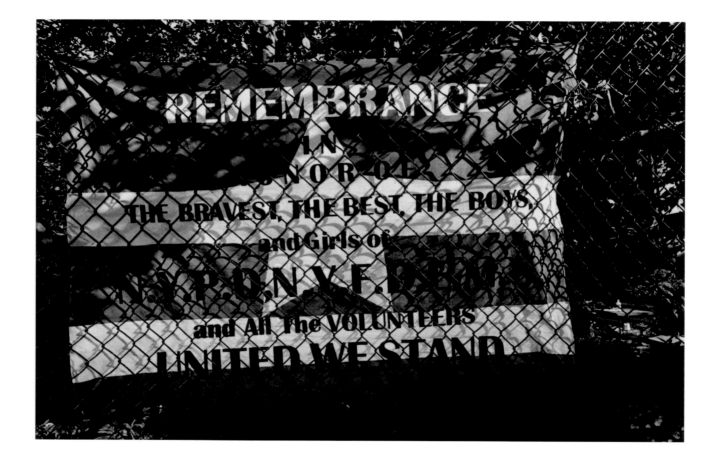

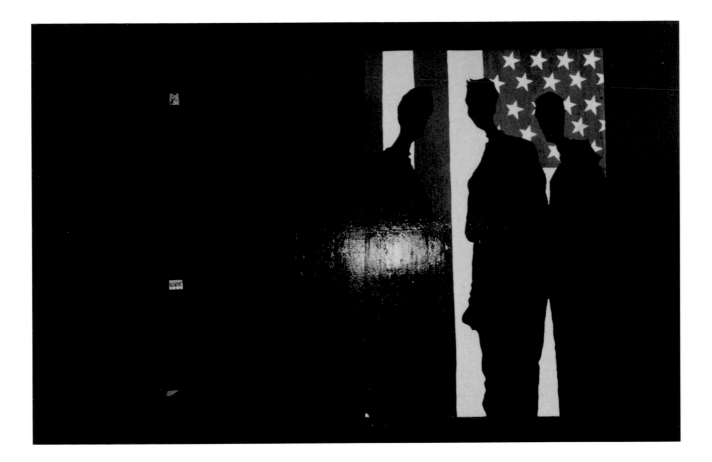

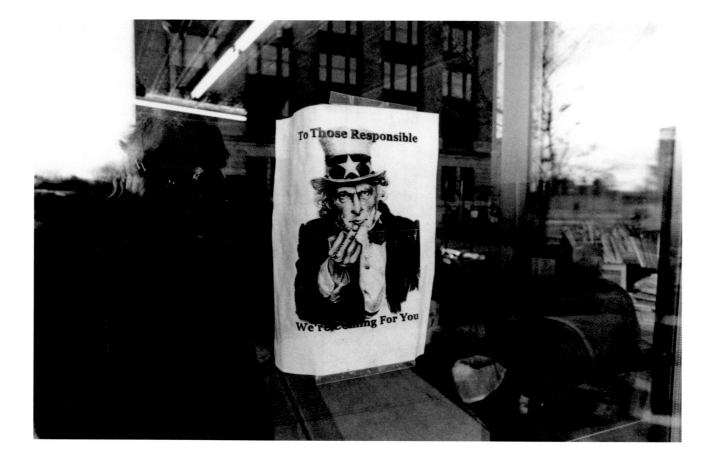

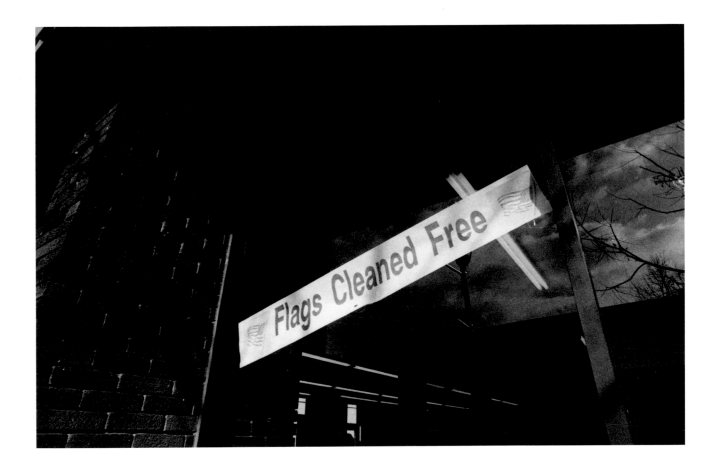

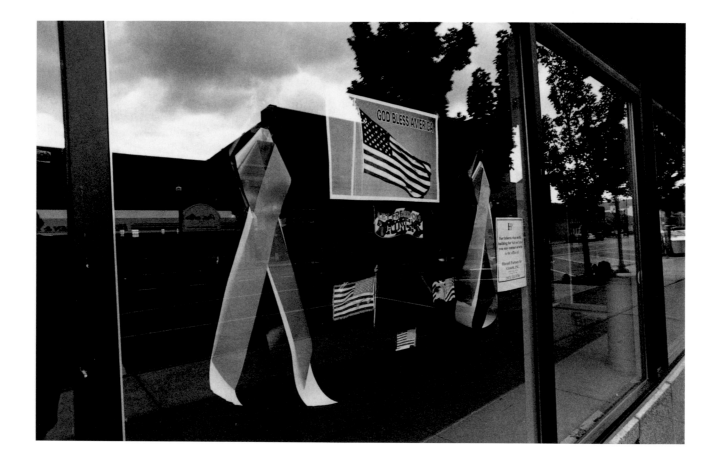

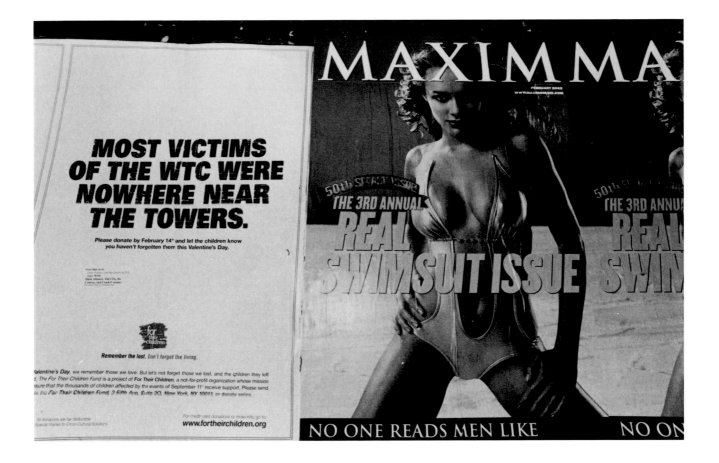

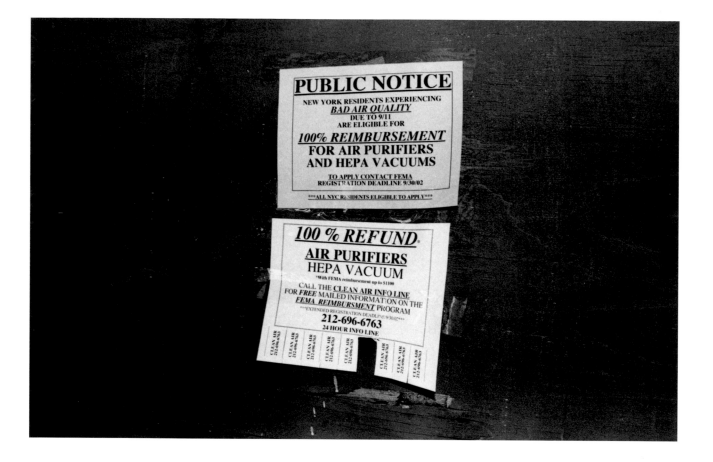

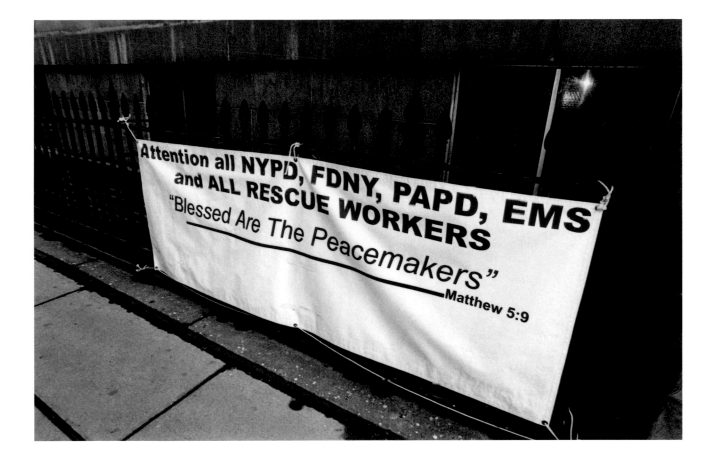

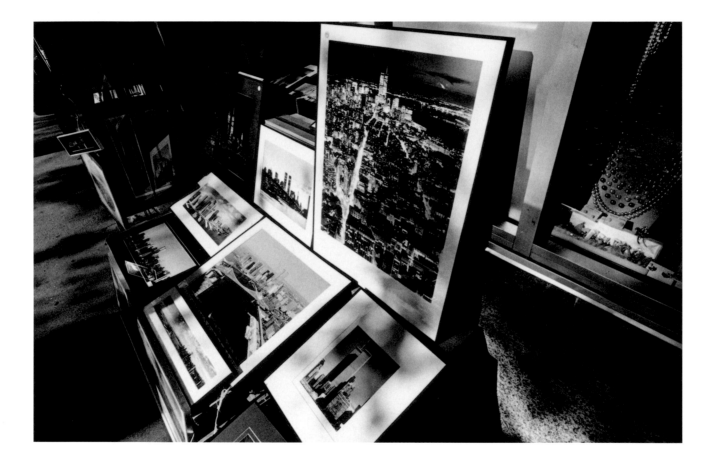

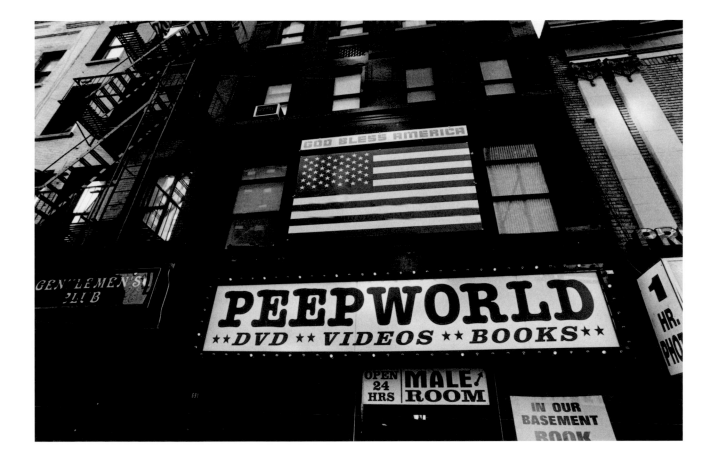

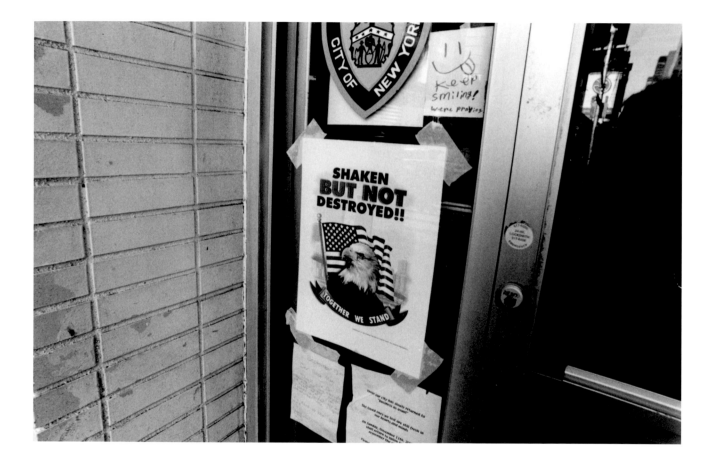

36

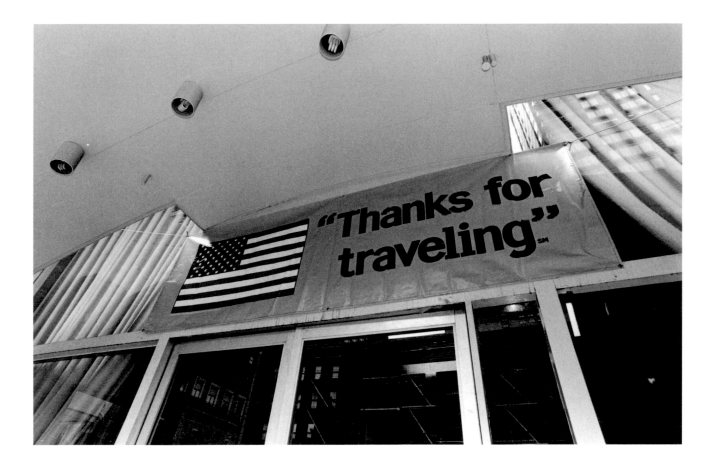

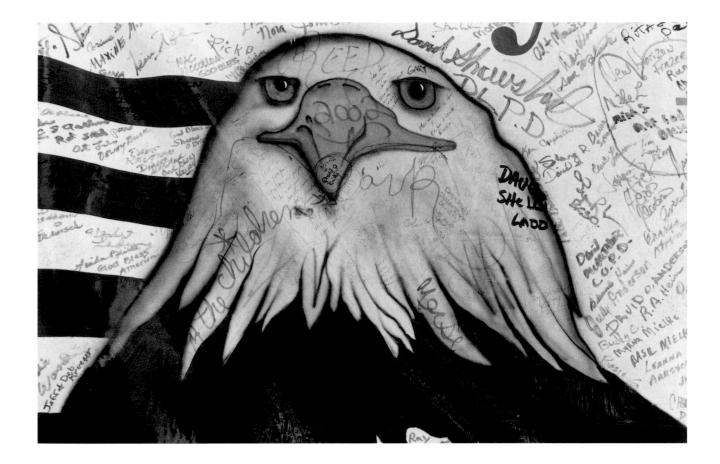

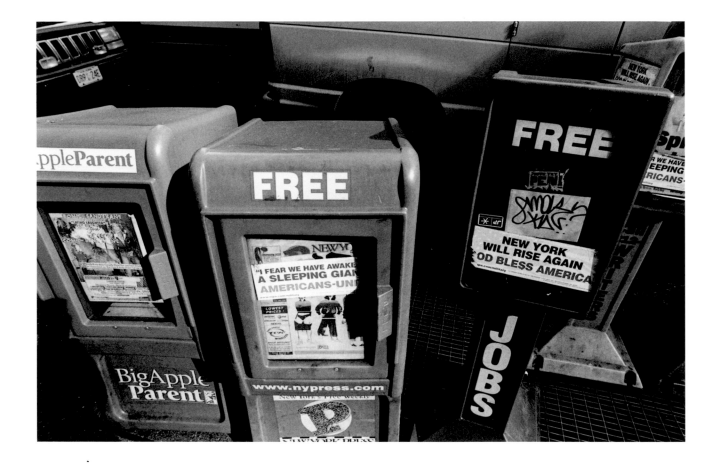

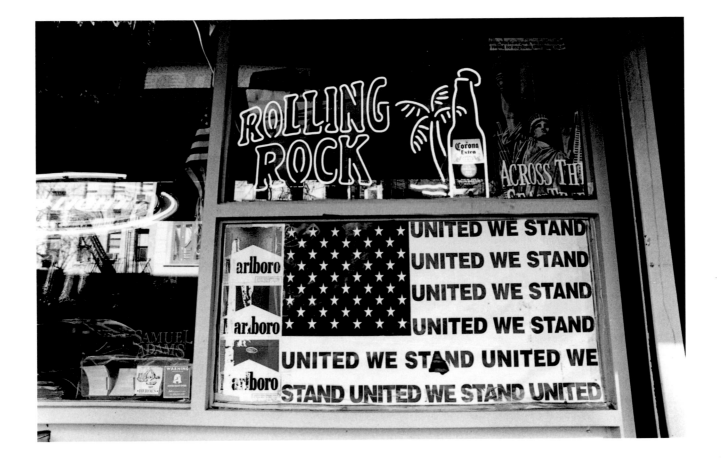

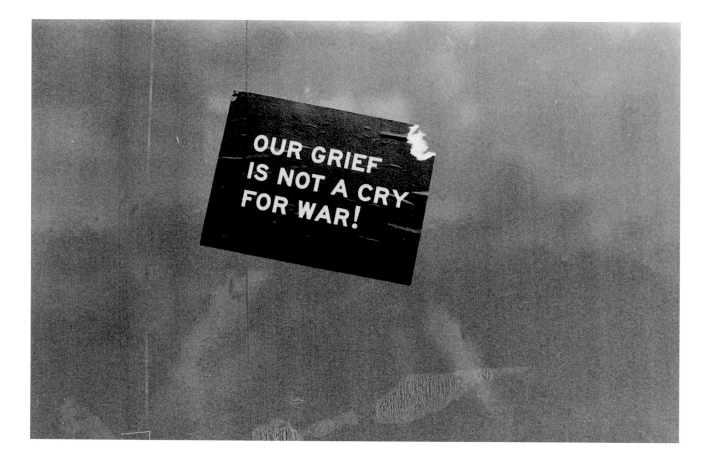

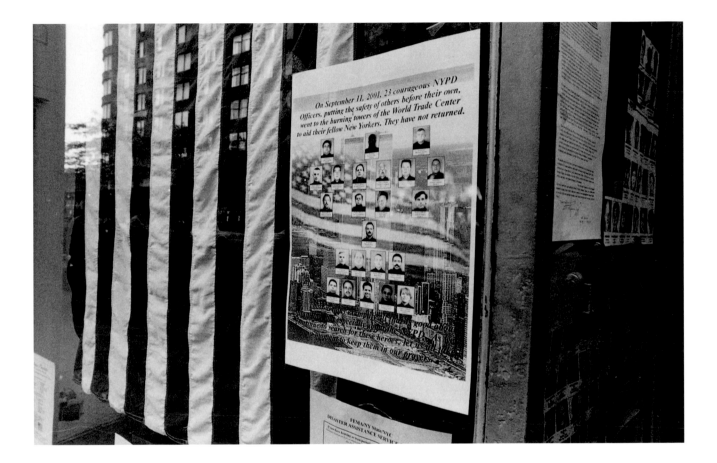

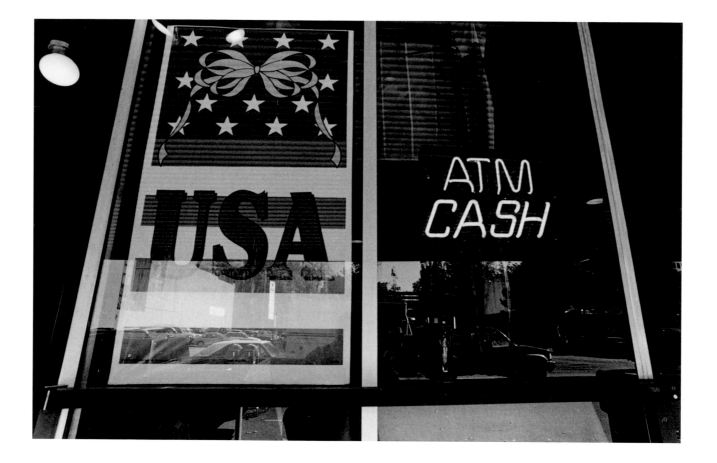

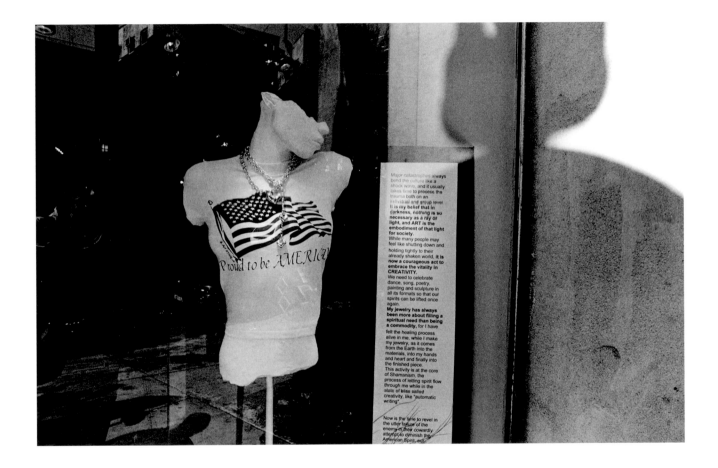

45

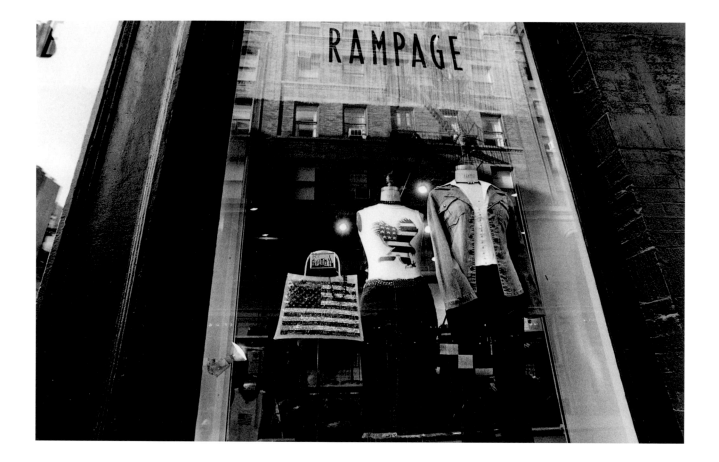

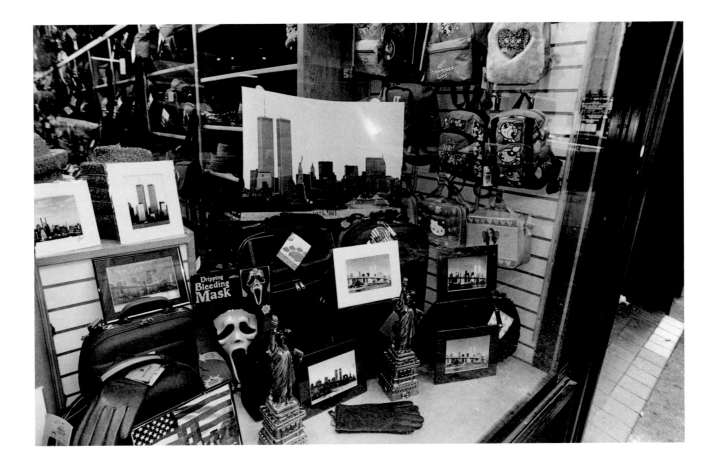

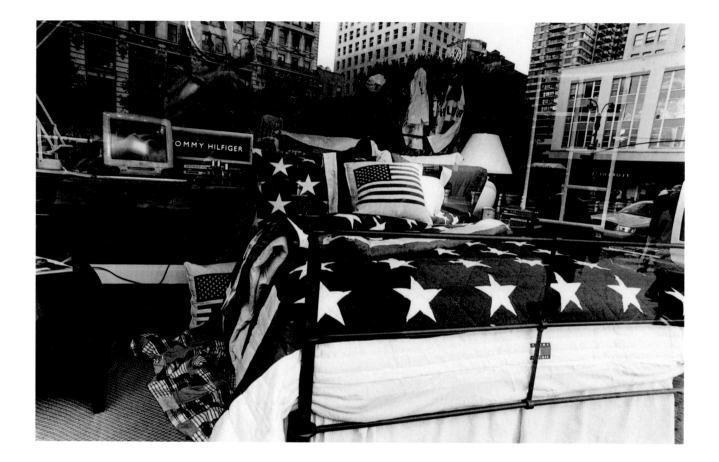

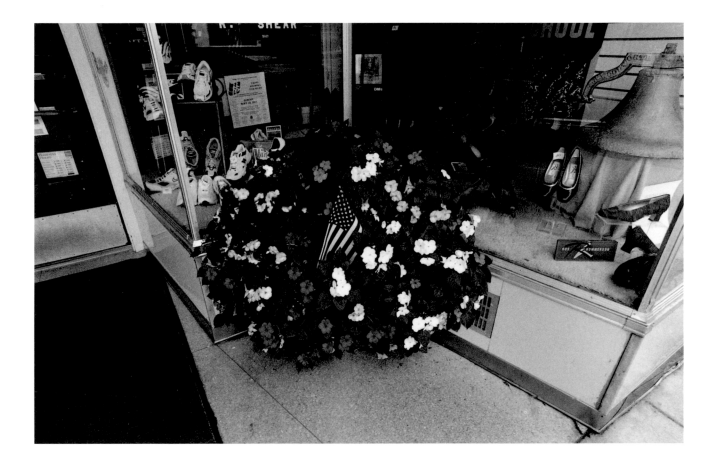

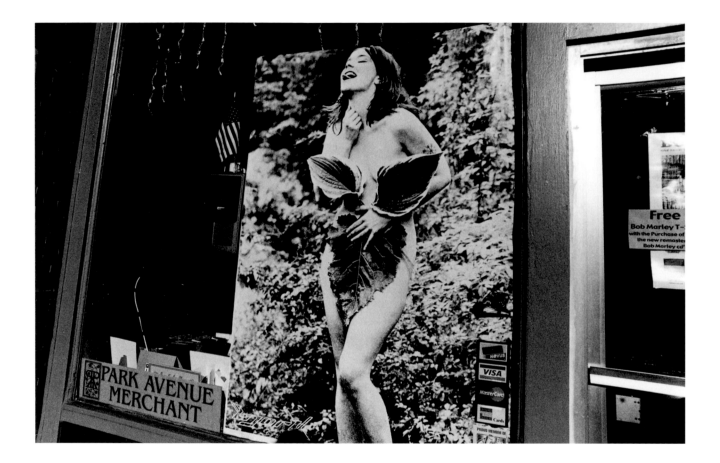

50

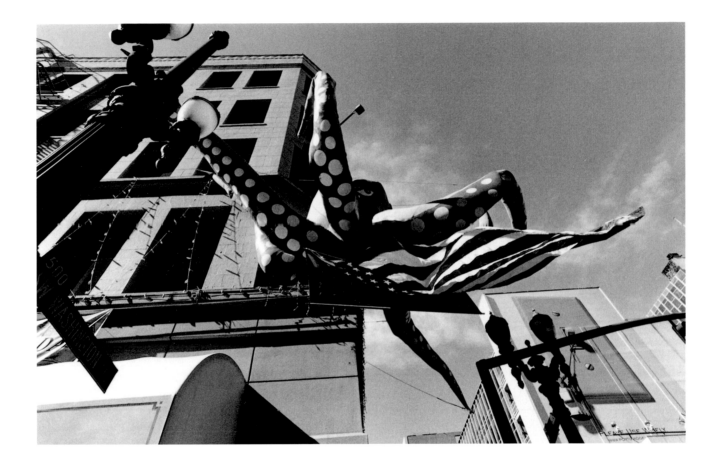

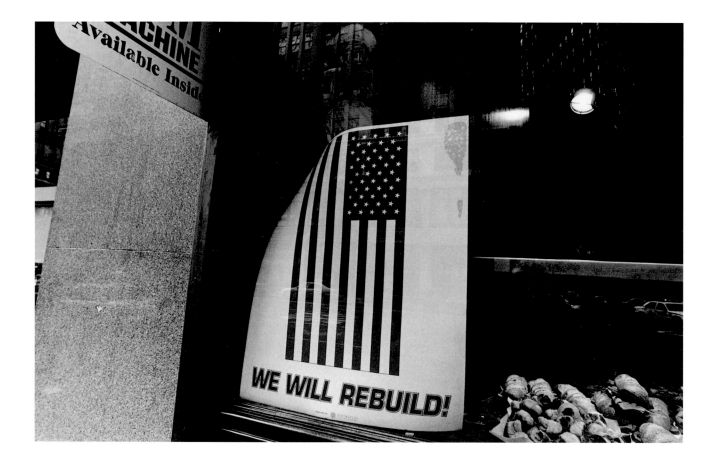

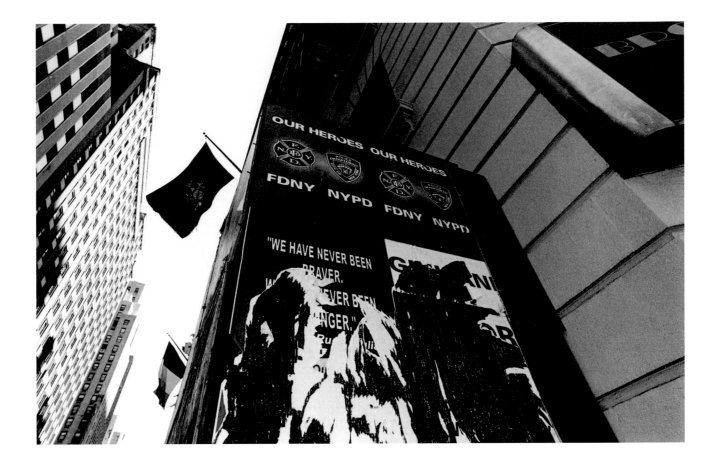

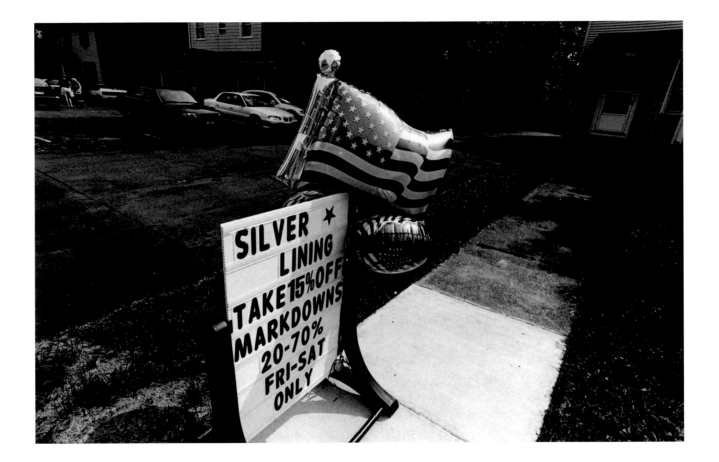

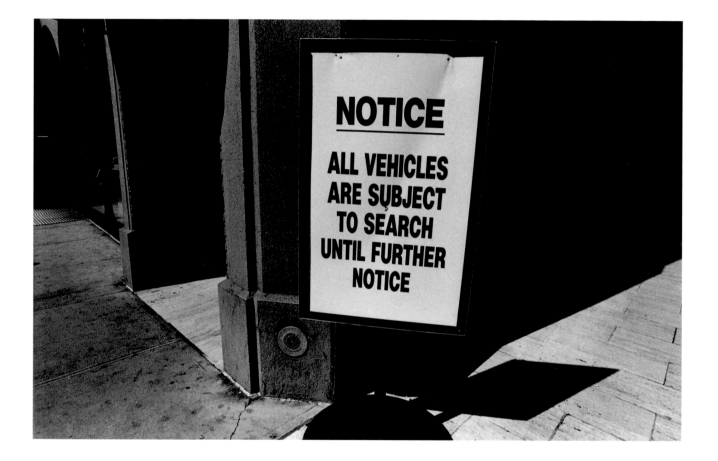

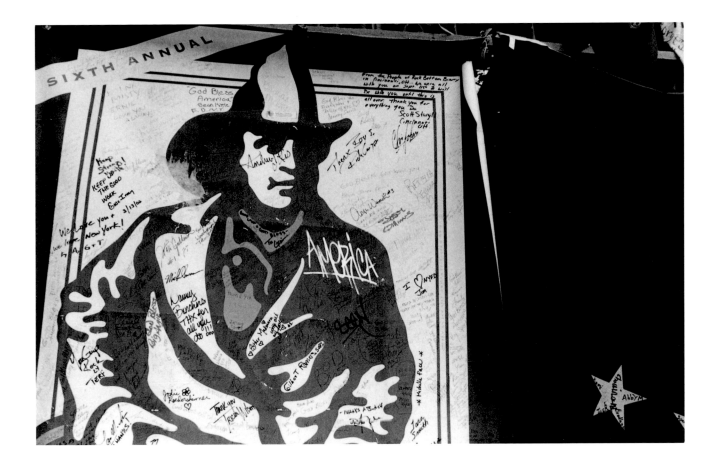

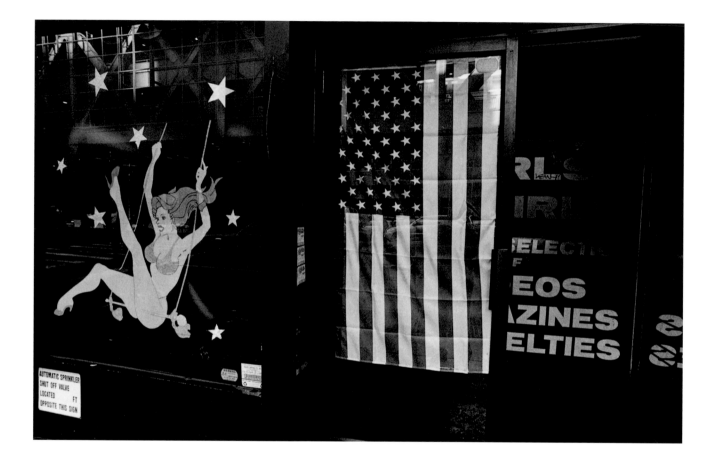

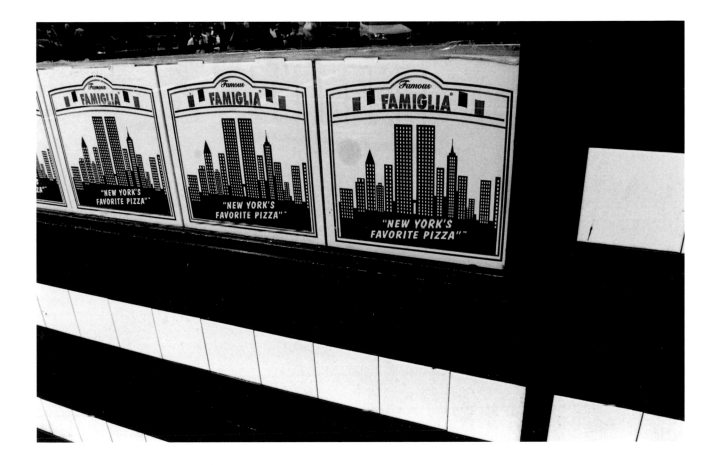

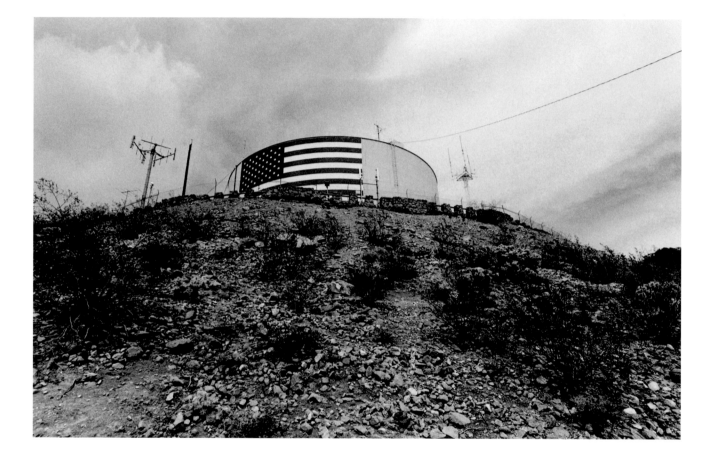

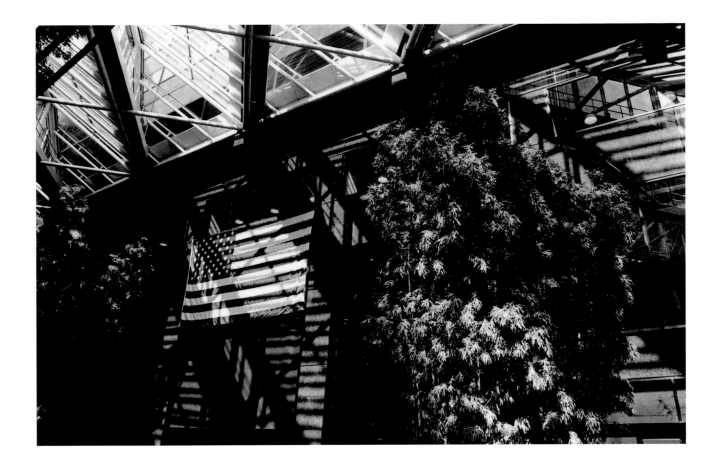

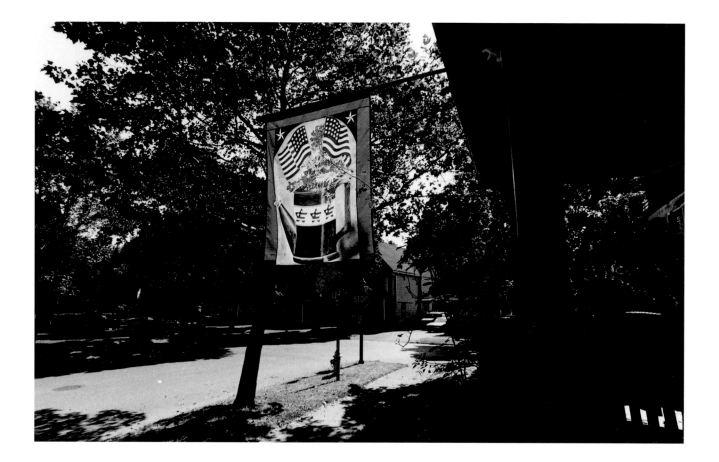

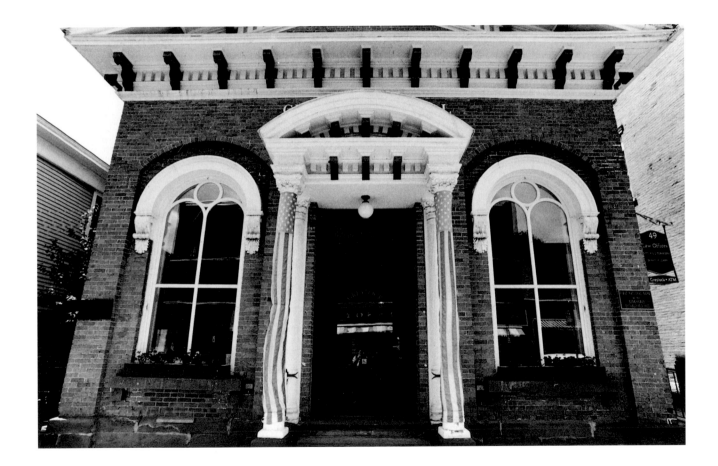

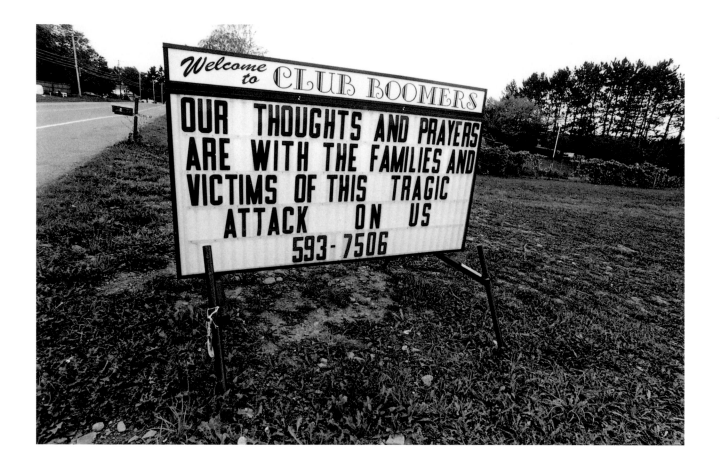

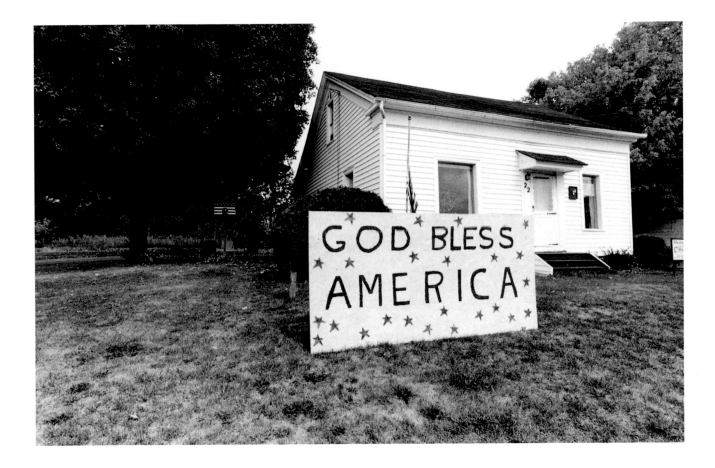

65

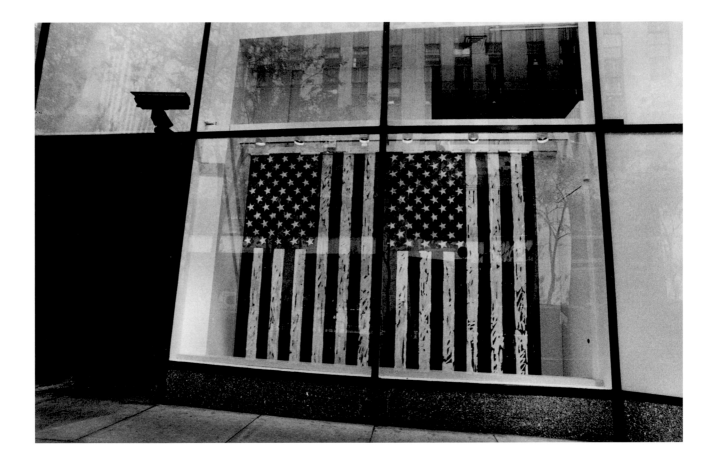

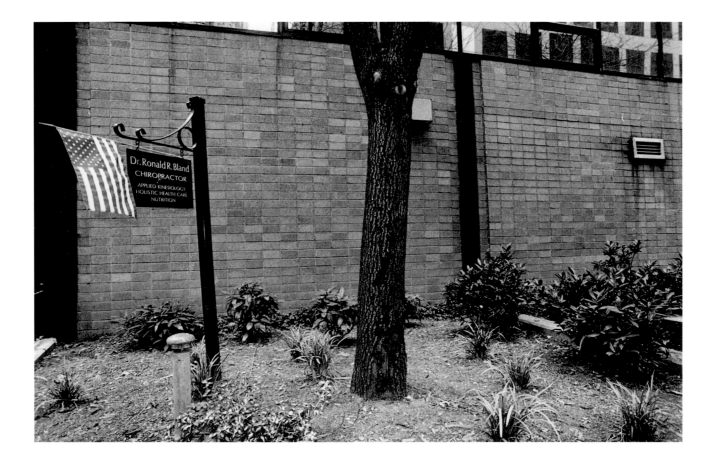

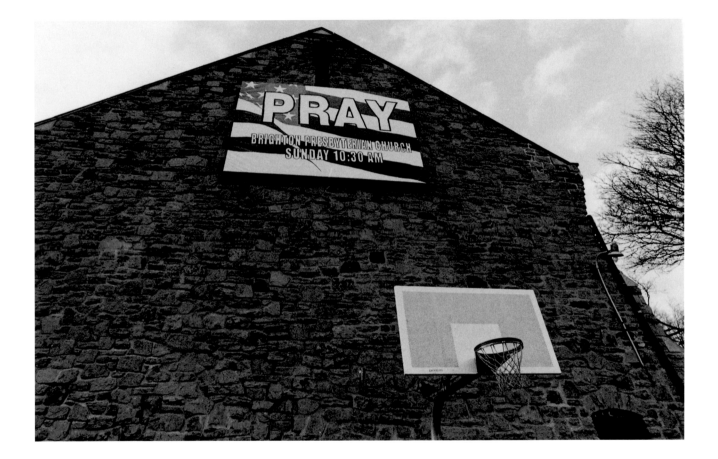

69

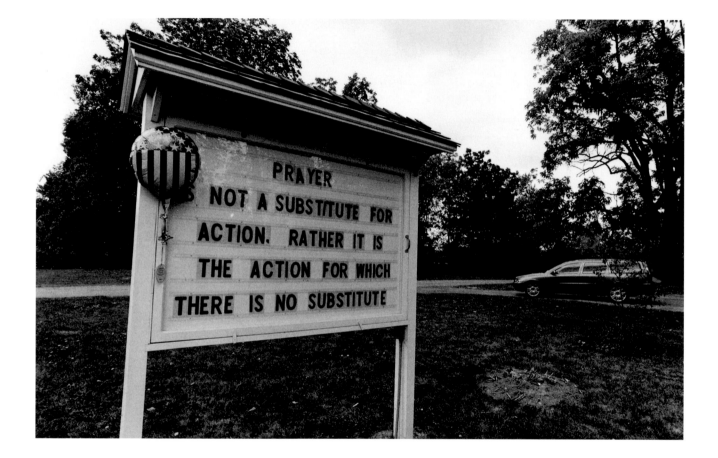

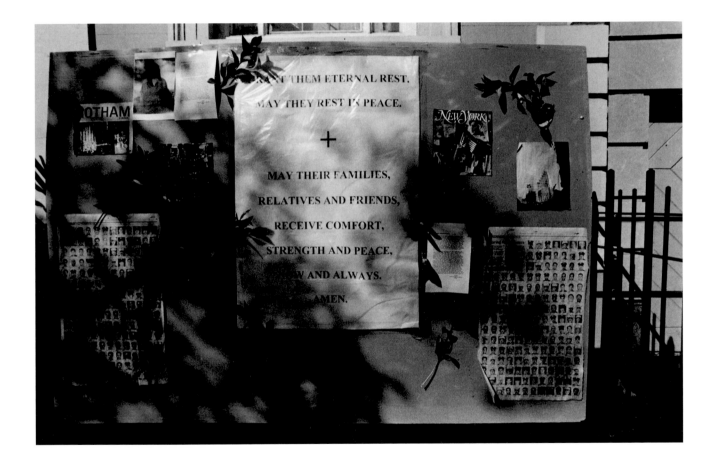

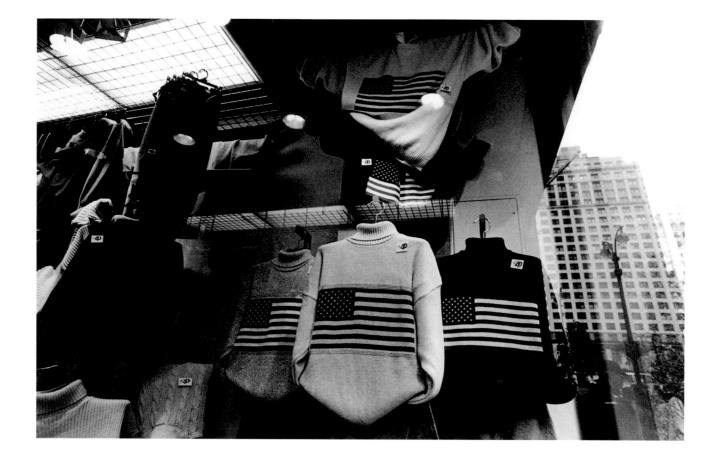

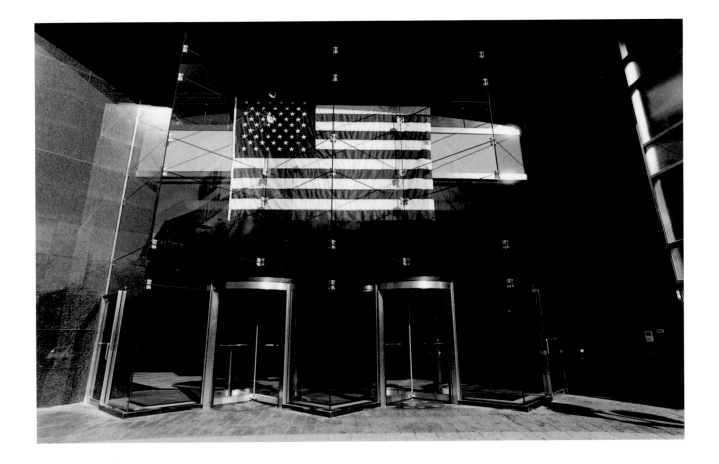

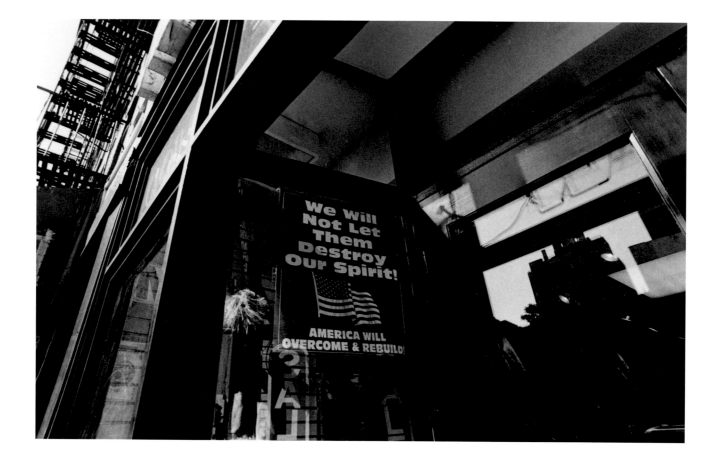

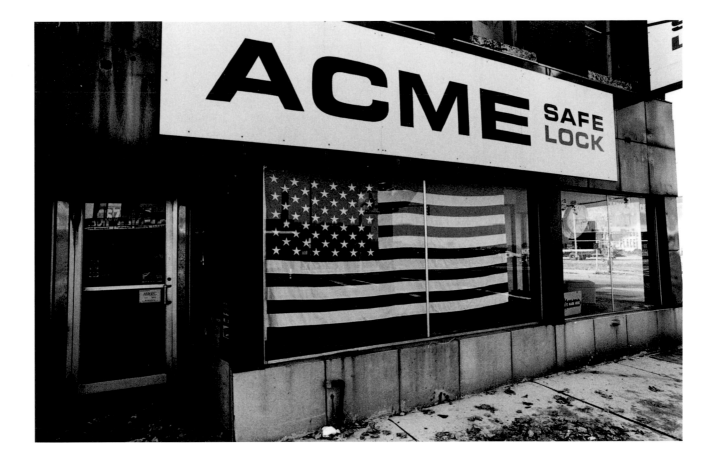

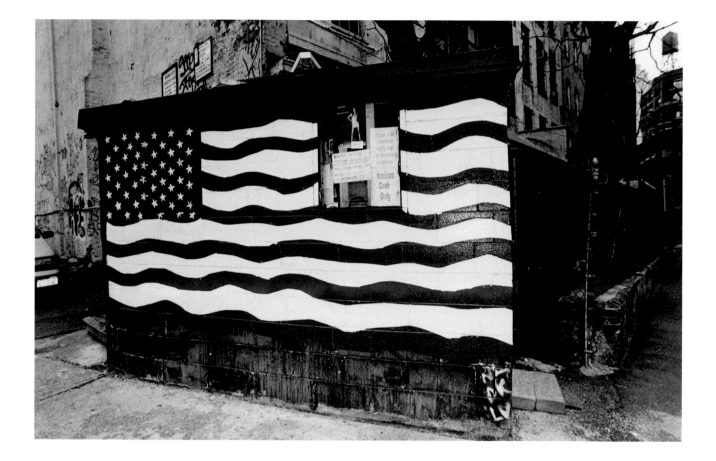

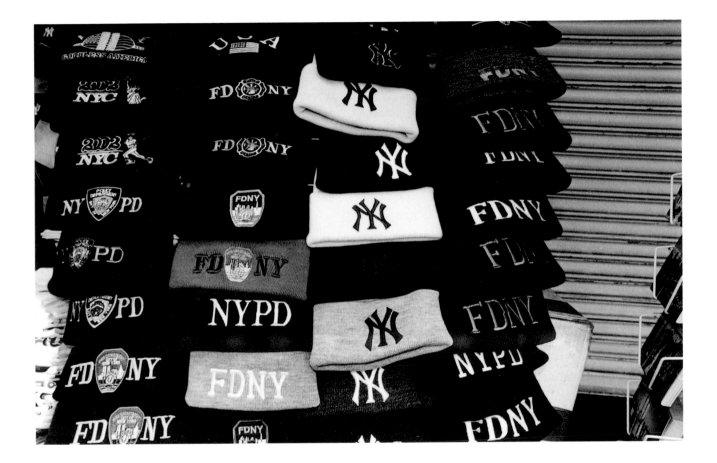

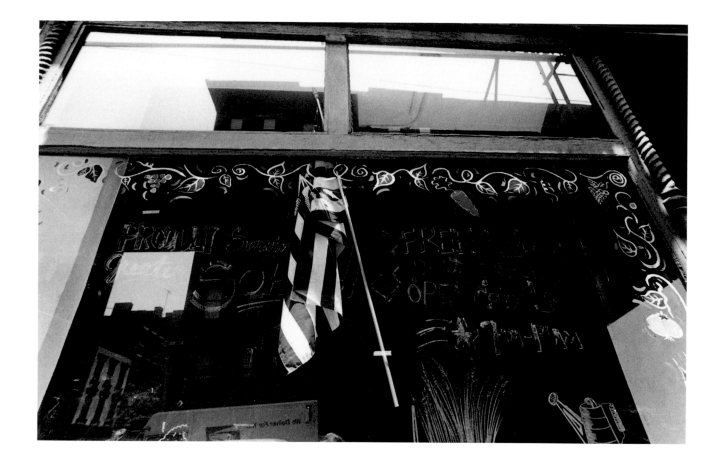

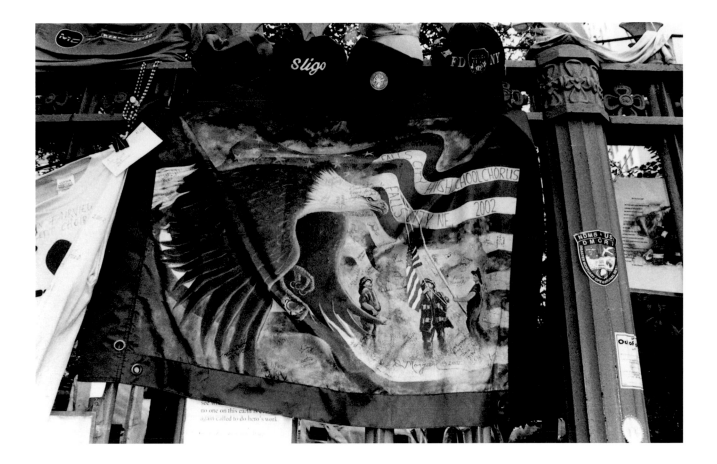

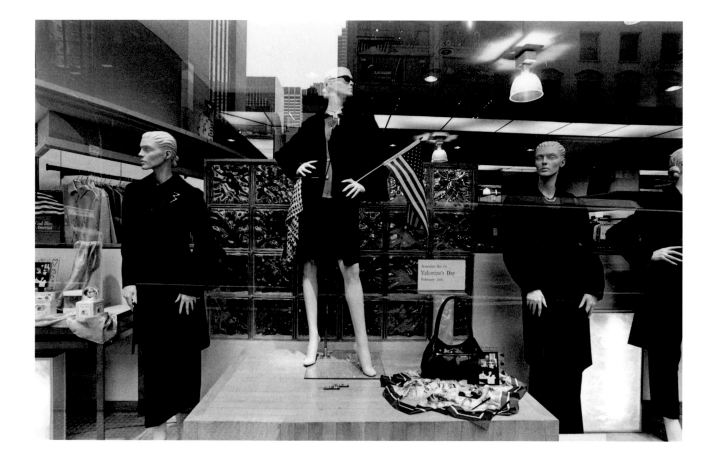

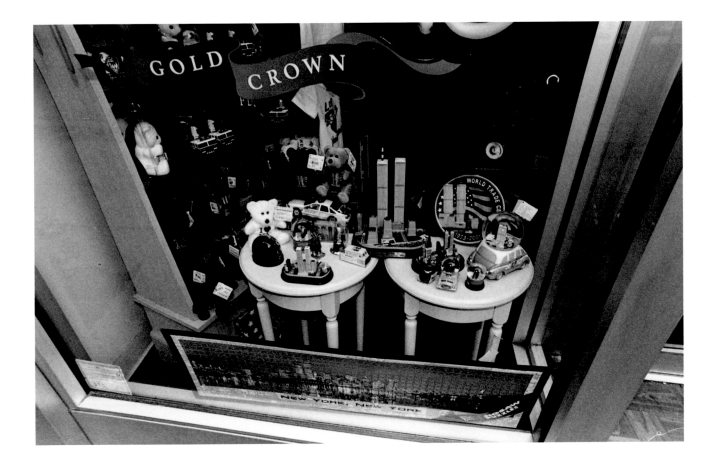

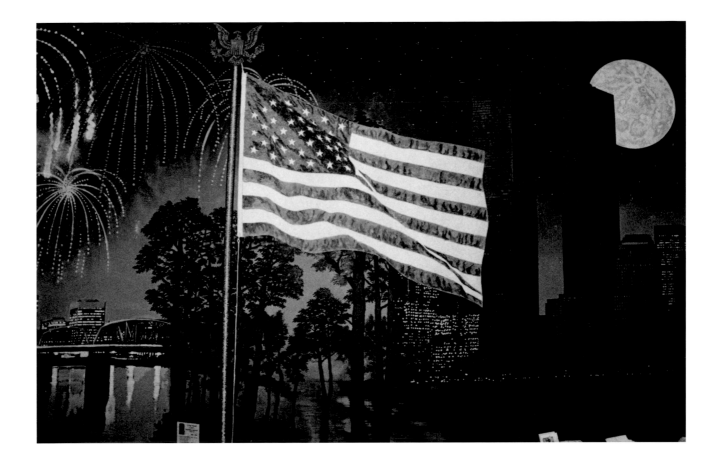

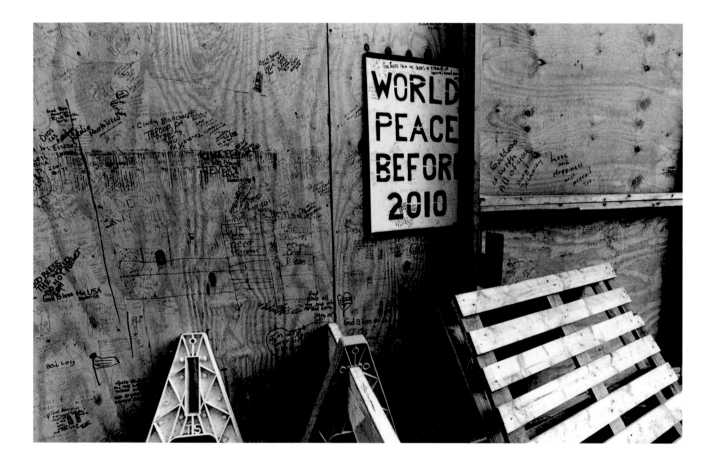

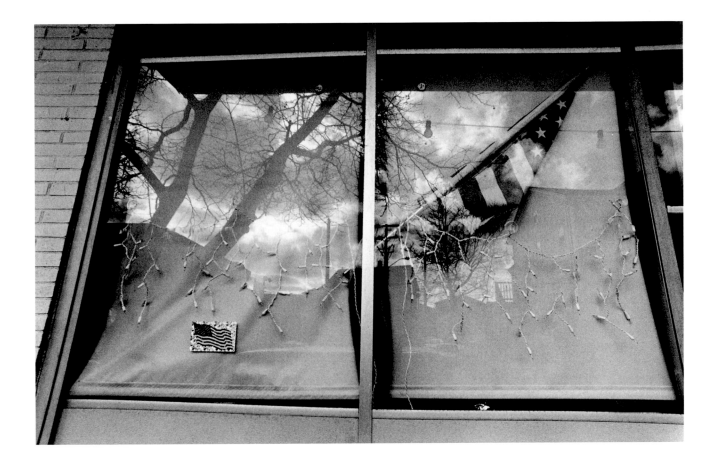

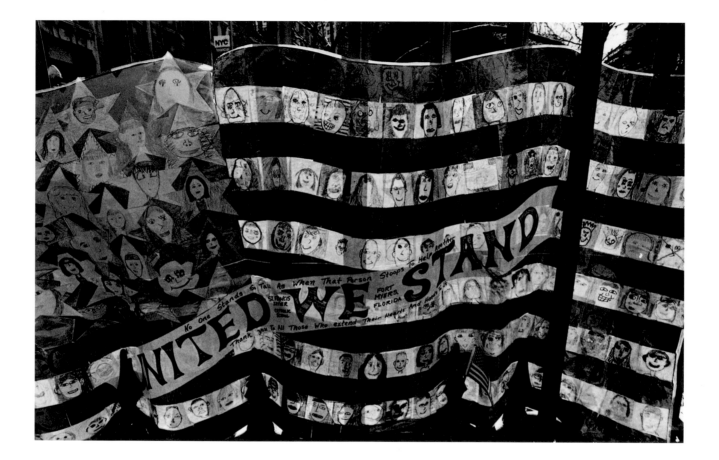

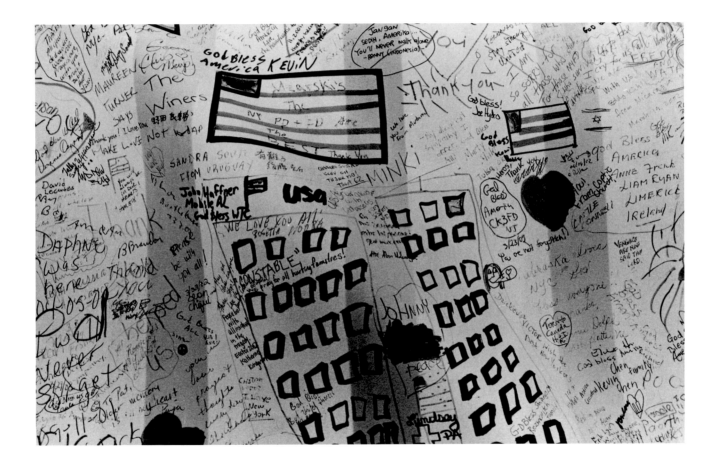

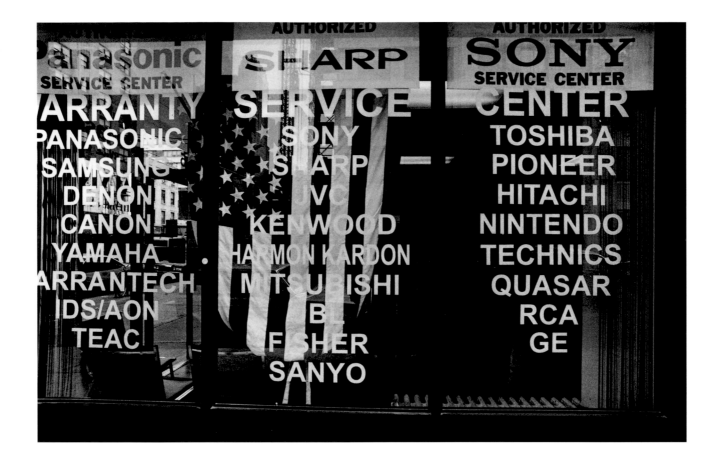

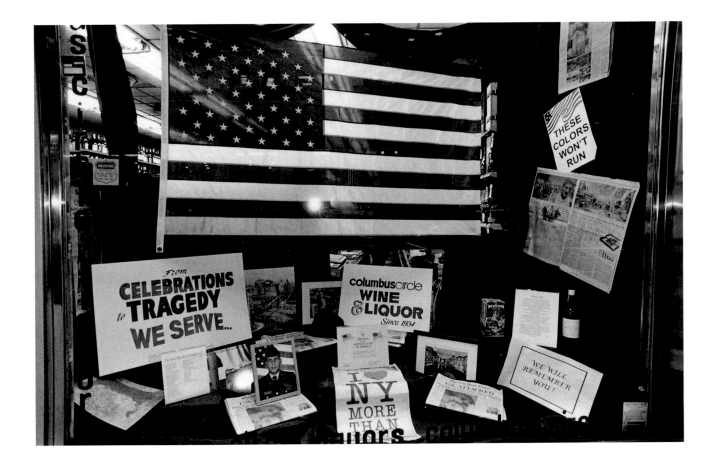

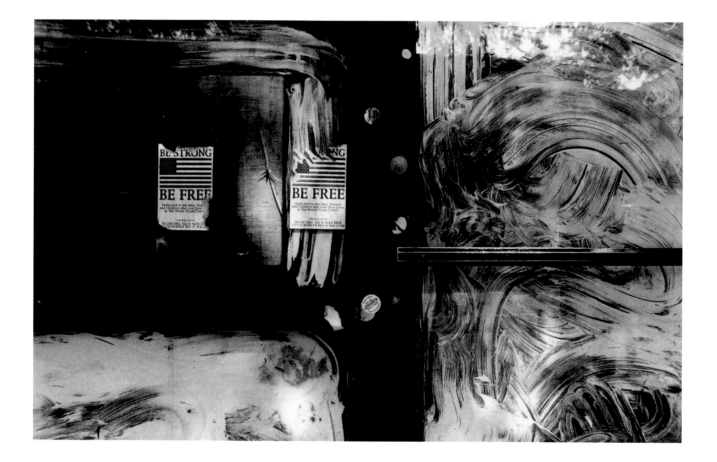

90

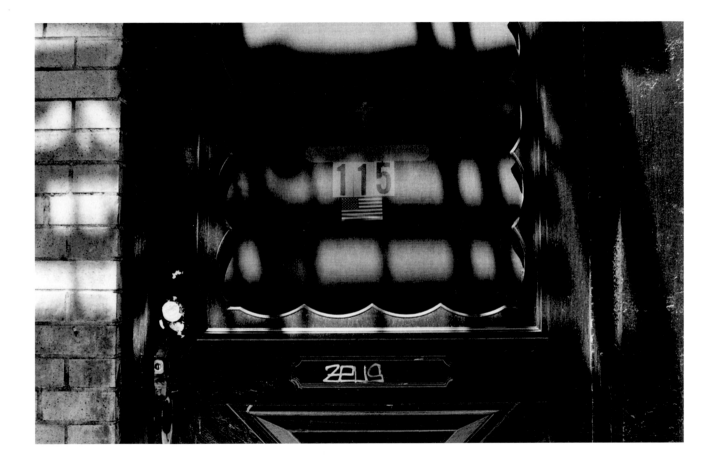

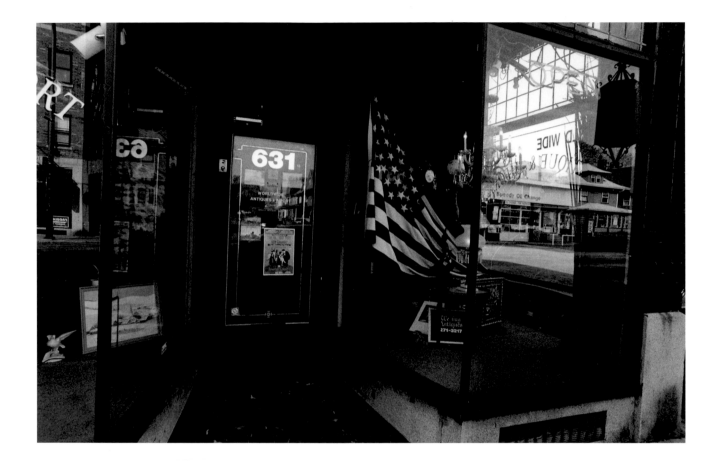

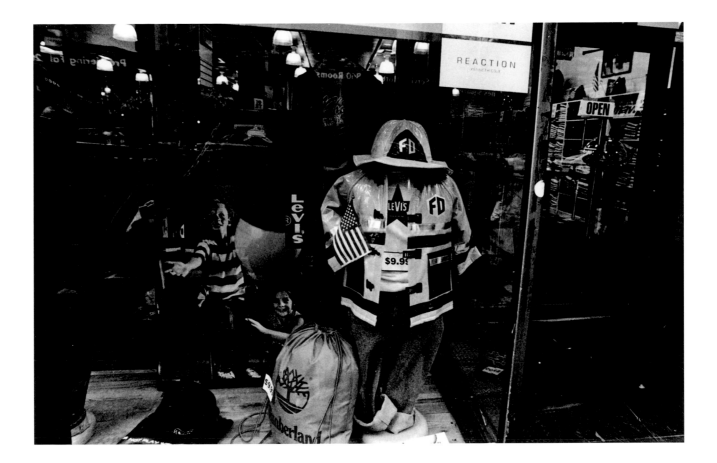

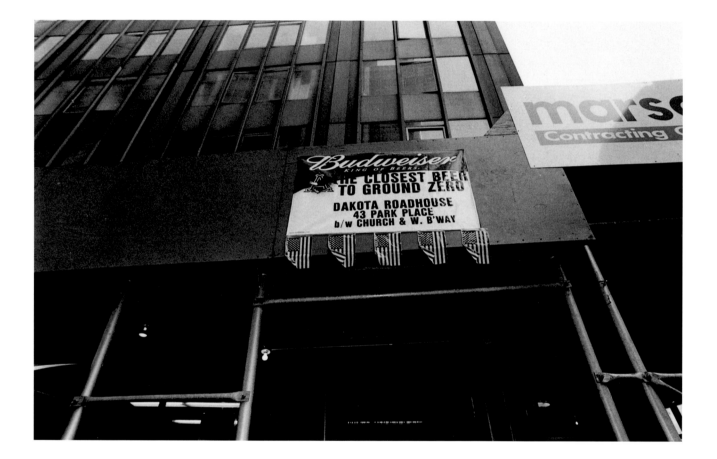

94

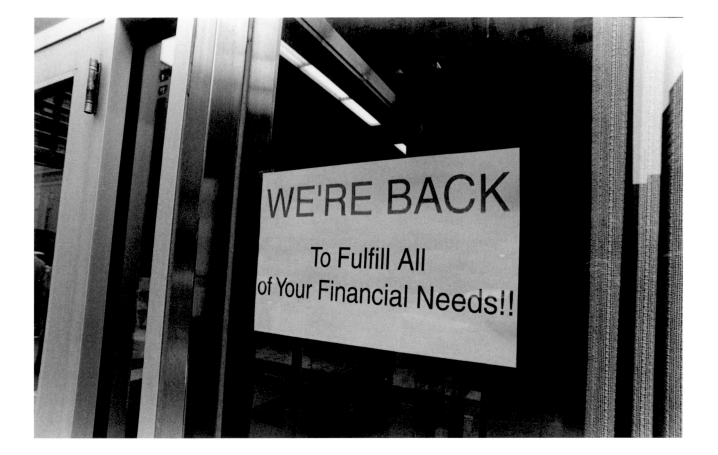

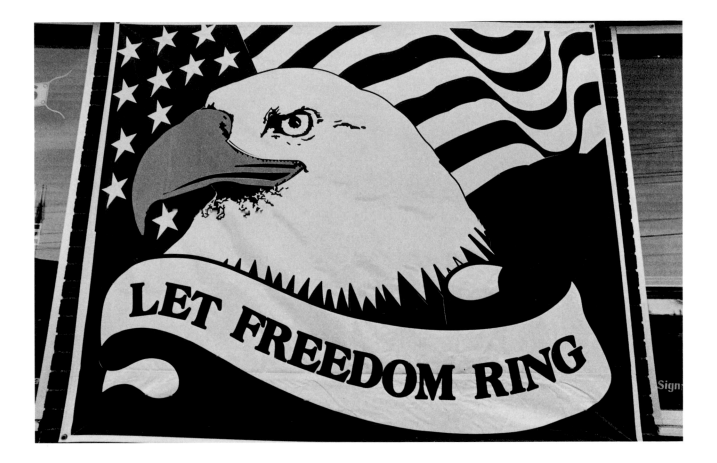

97

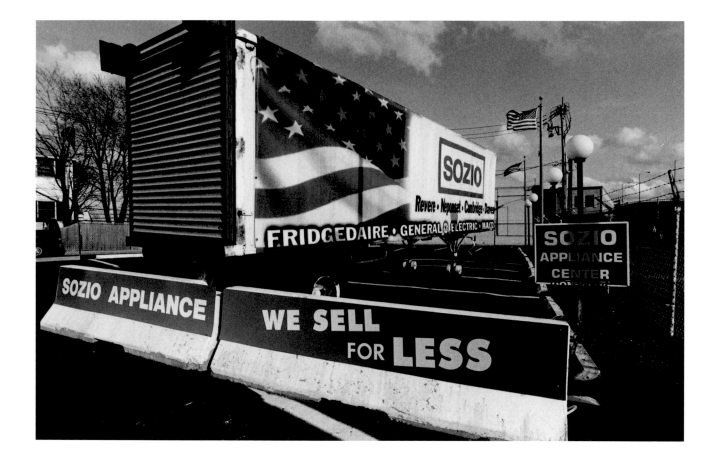

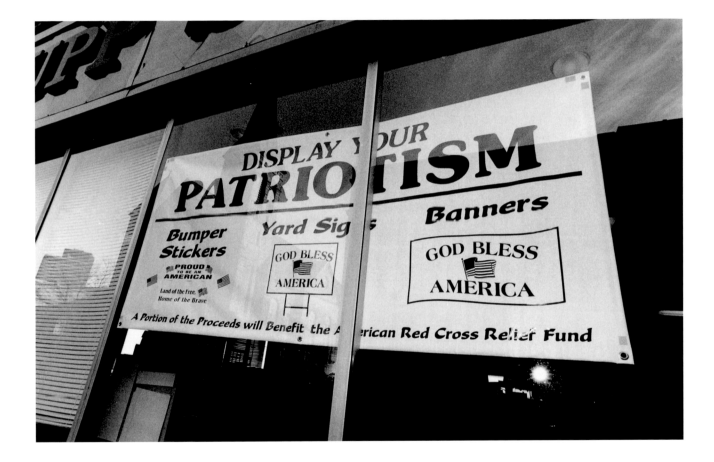

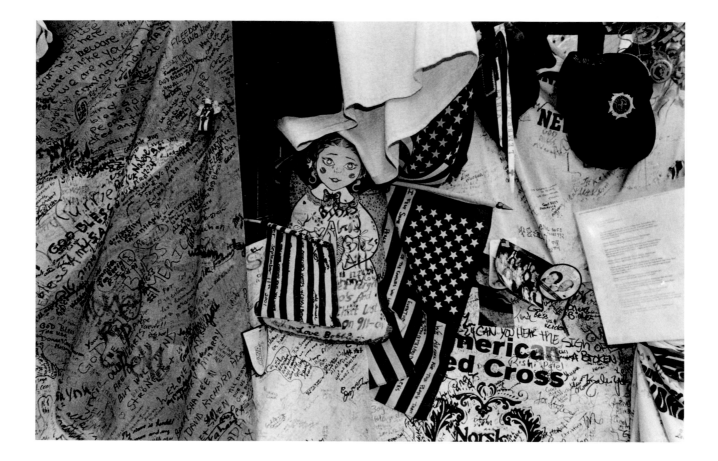

100

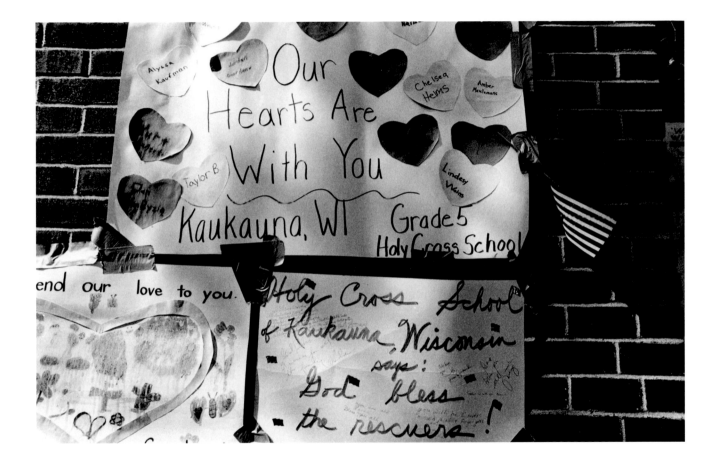

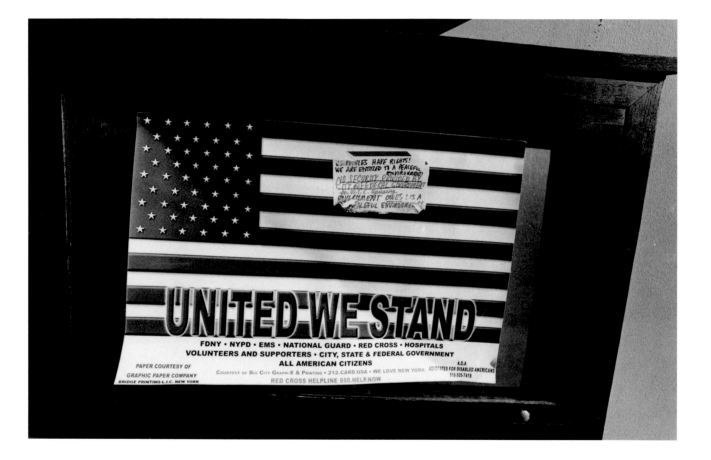

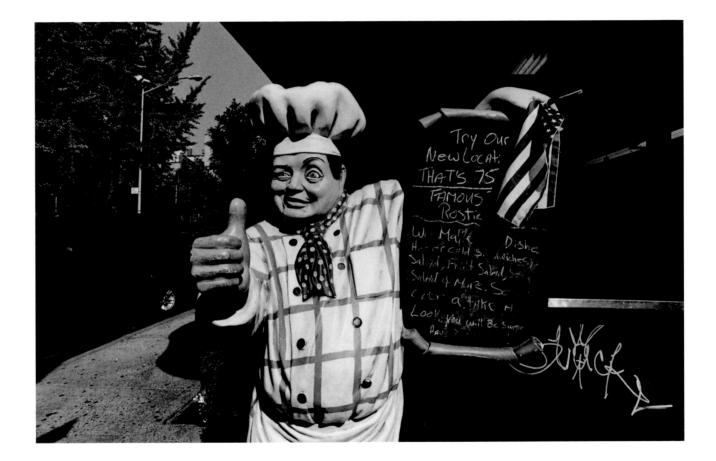

103

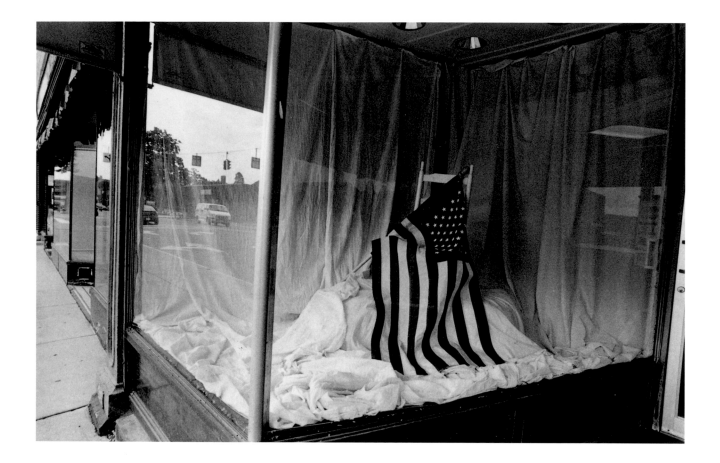

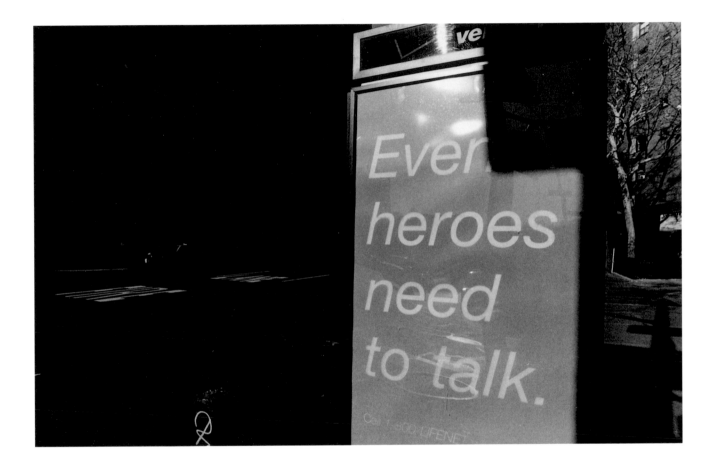

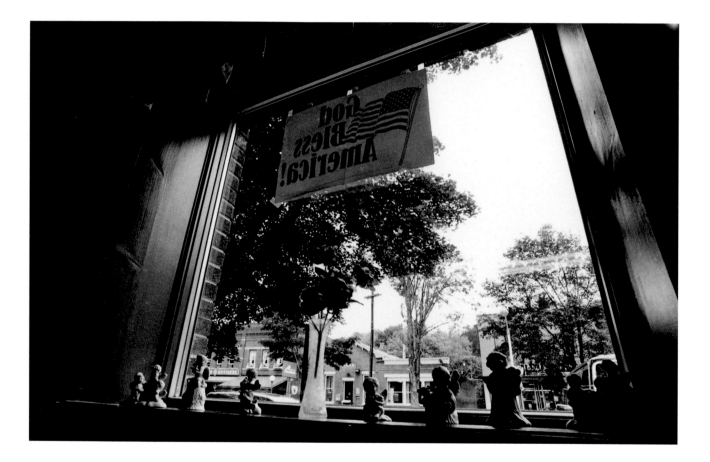

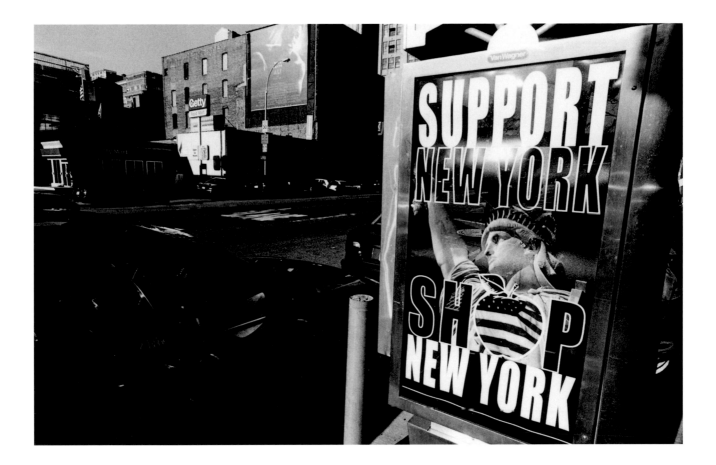

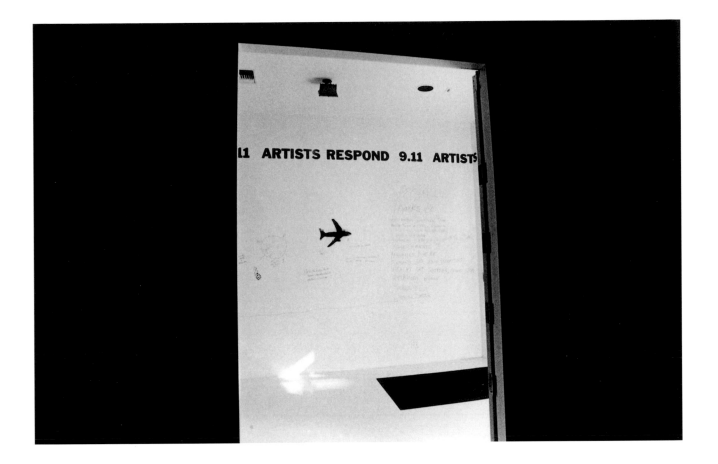

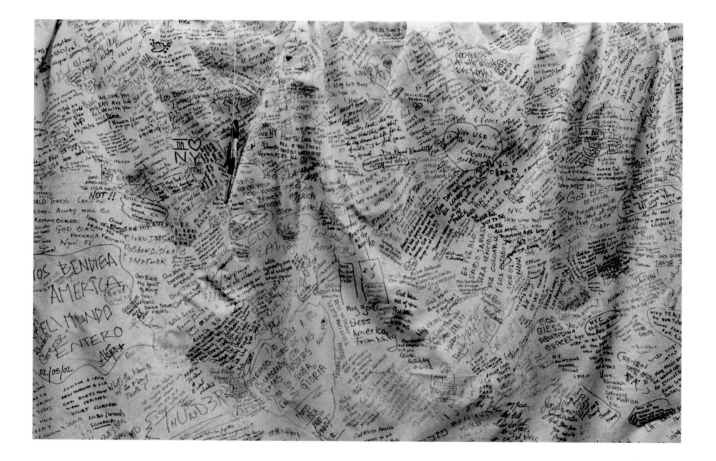

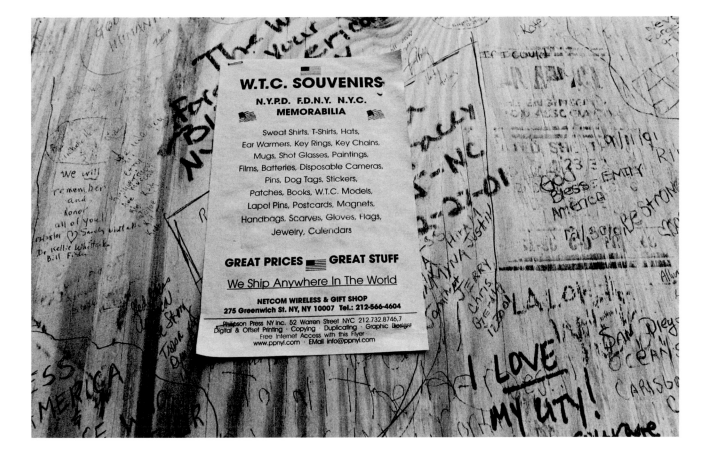

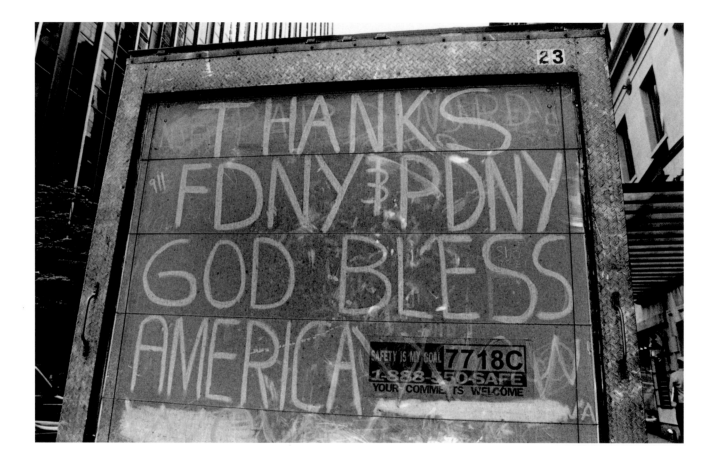

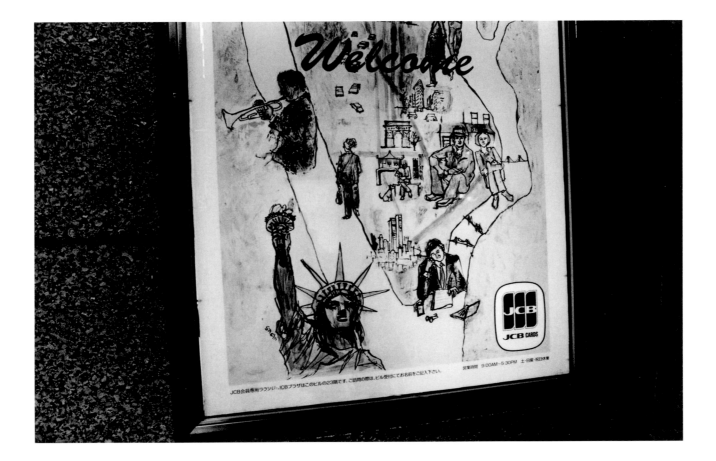

113

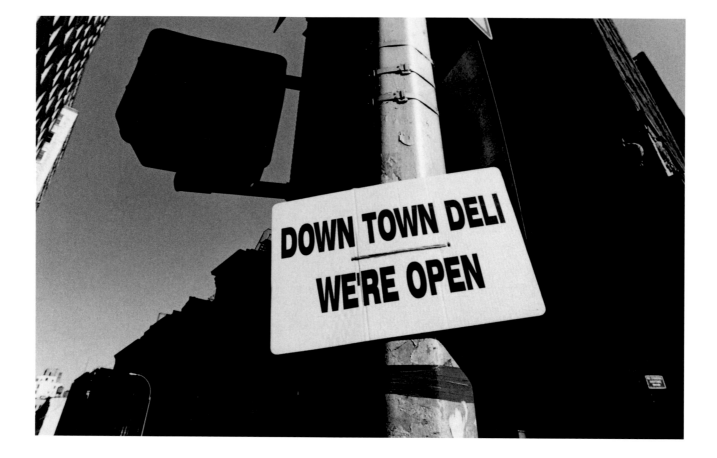

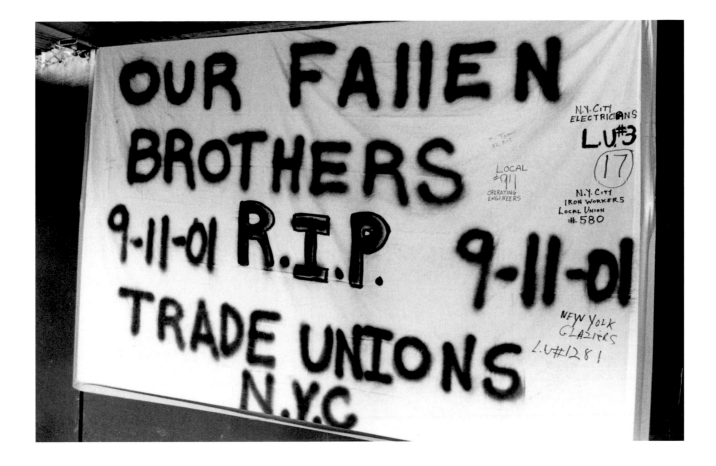

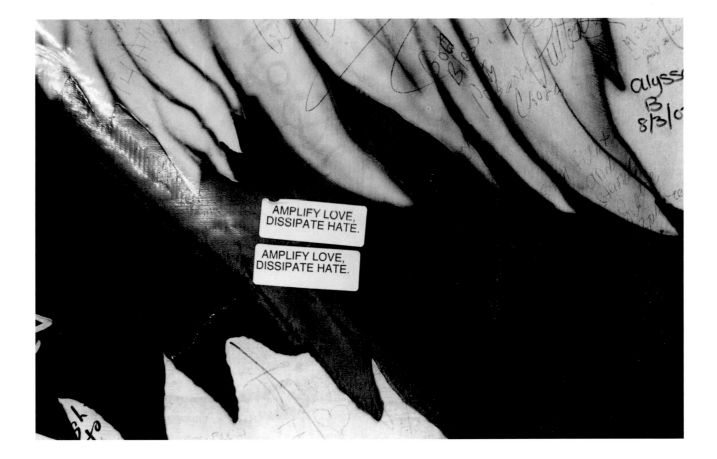

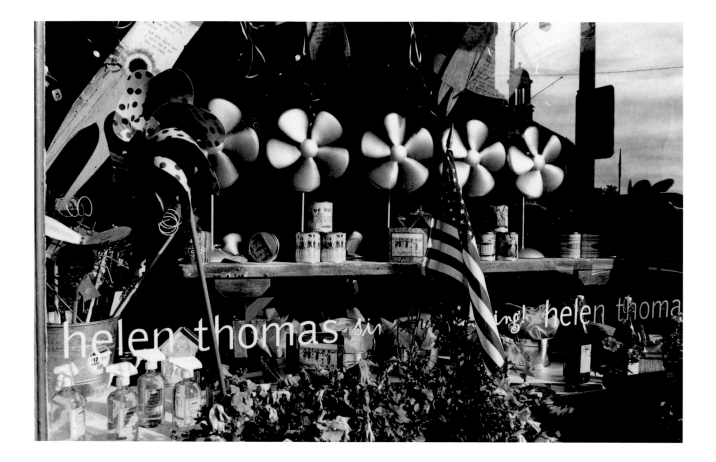

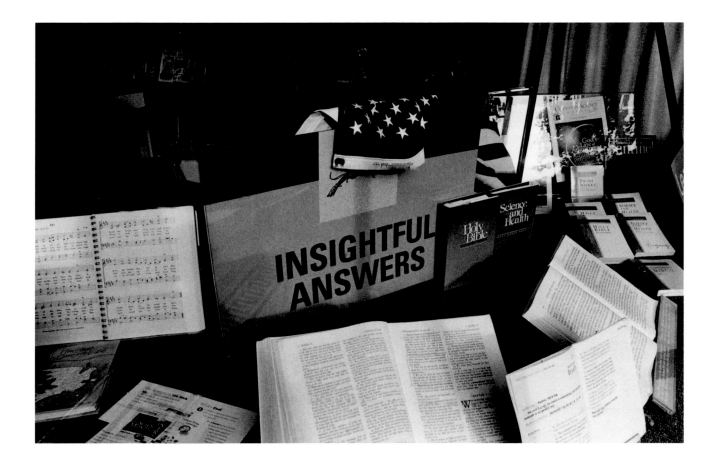

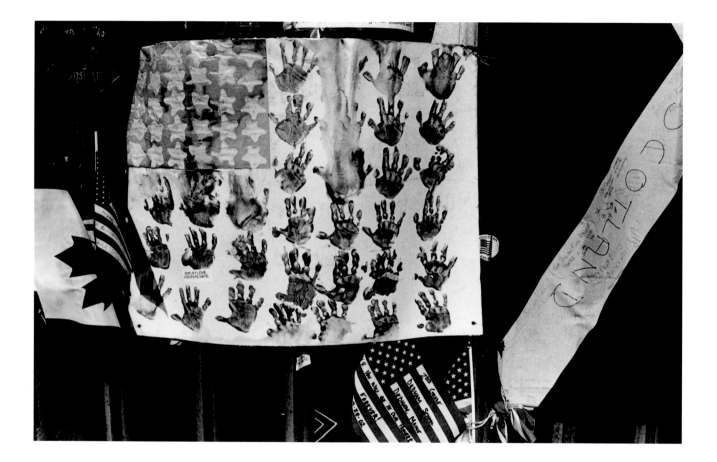

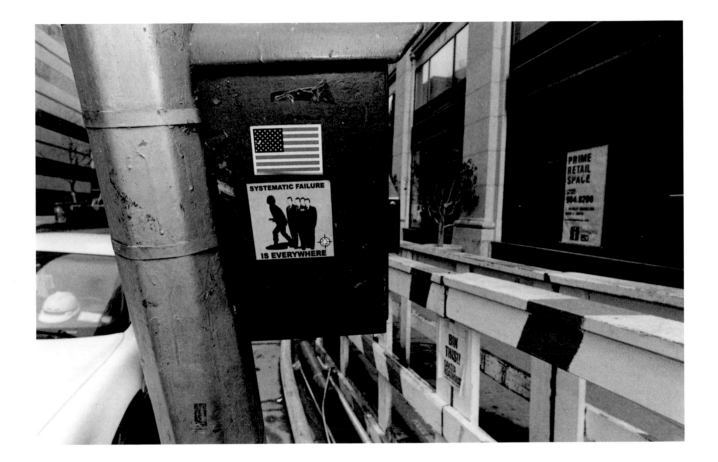

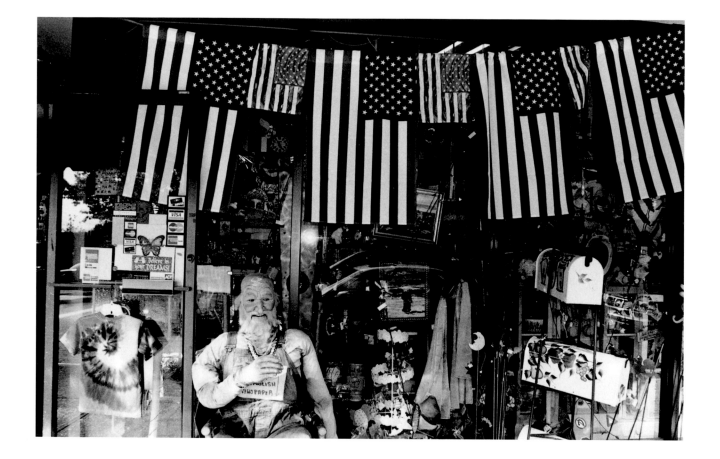

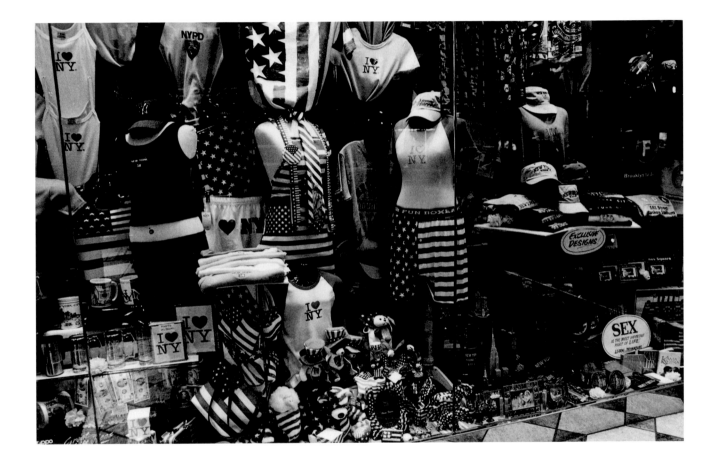

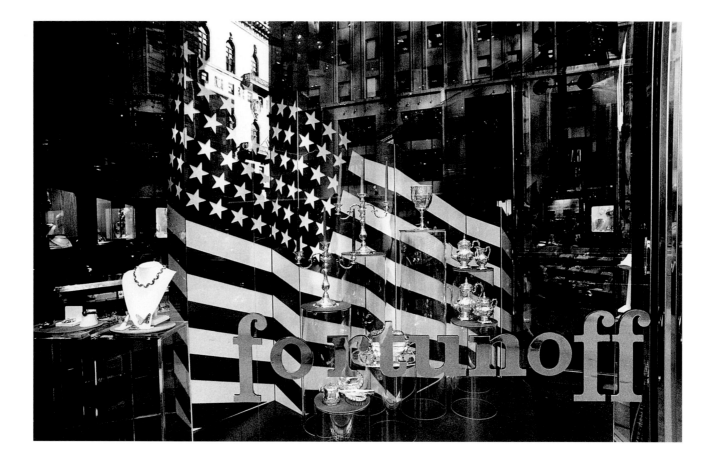

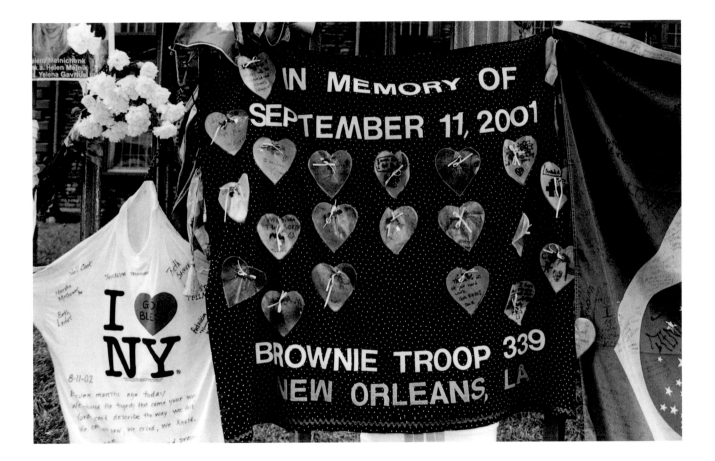

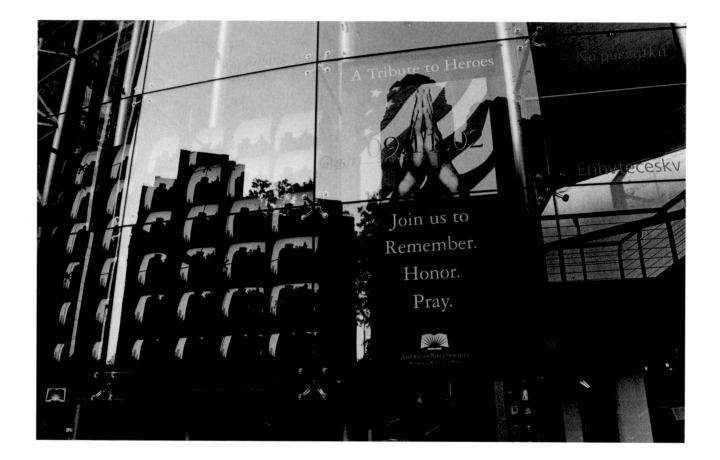

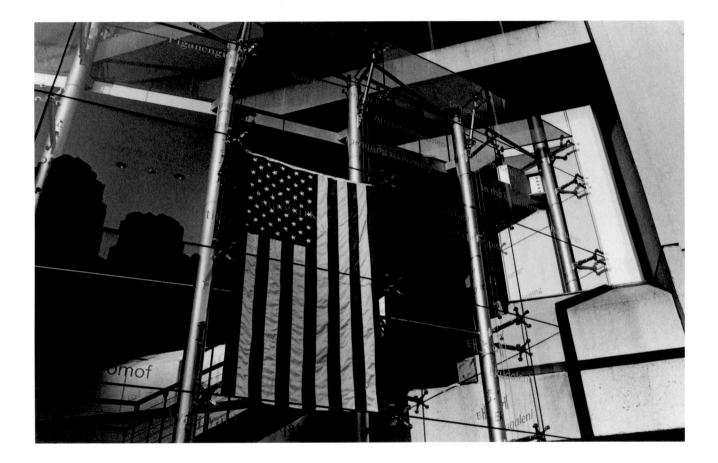

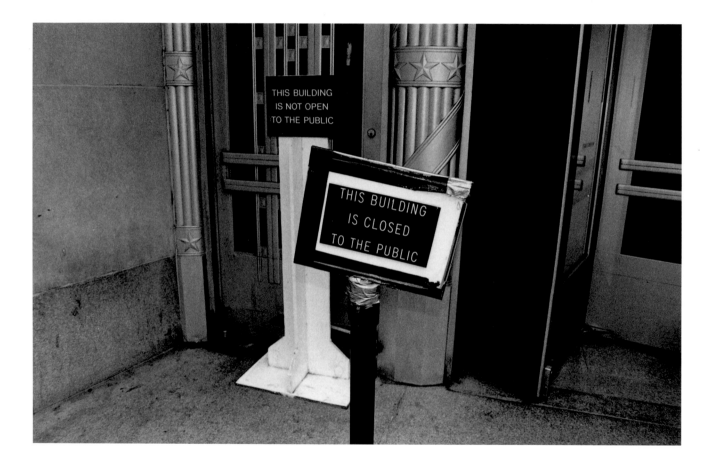

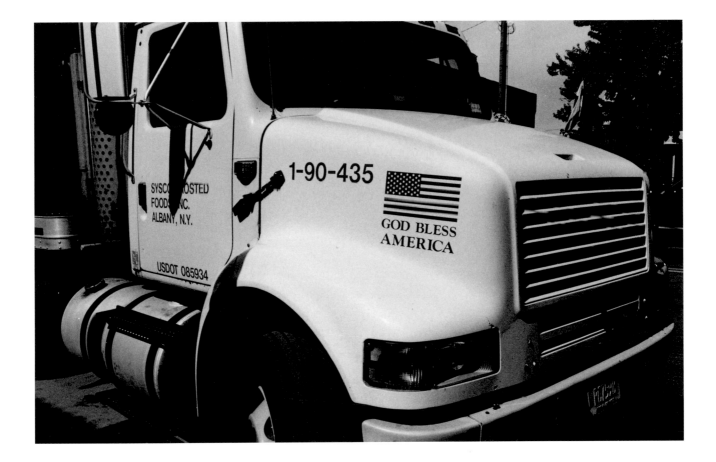

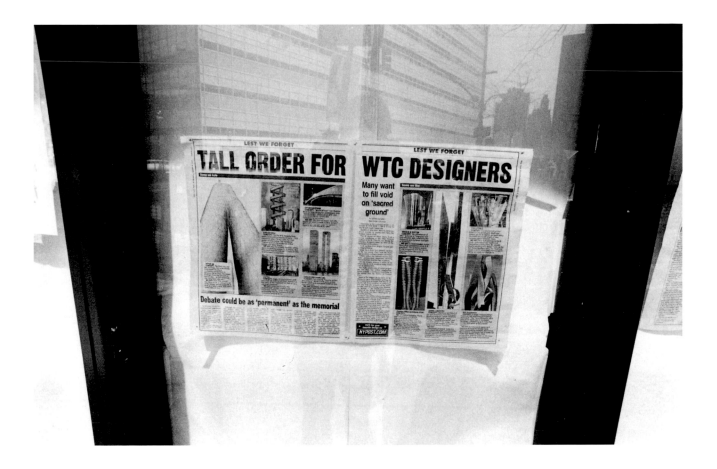

131

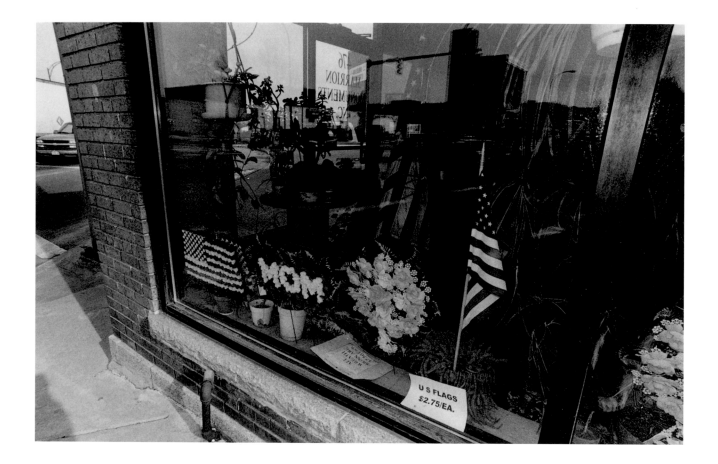

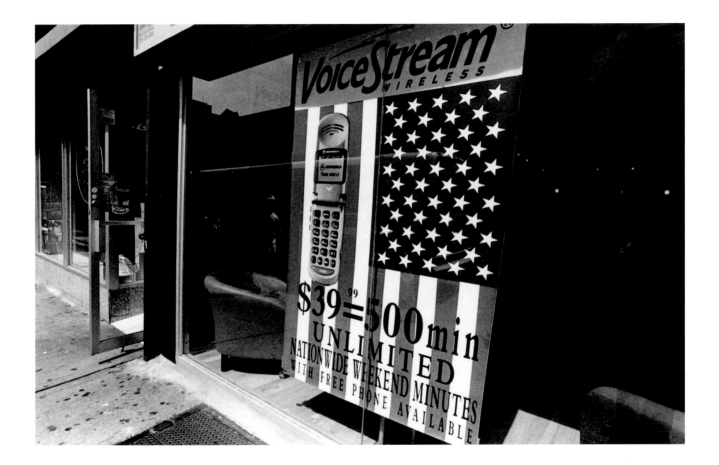

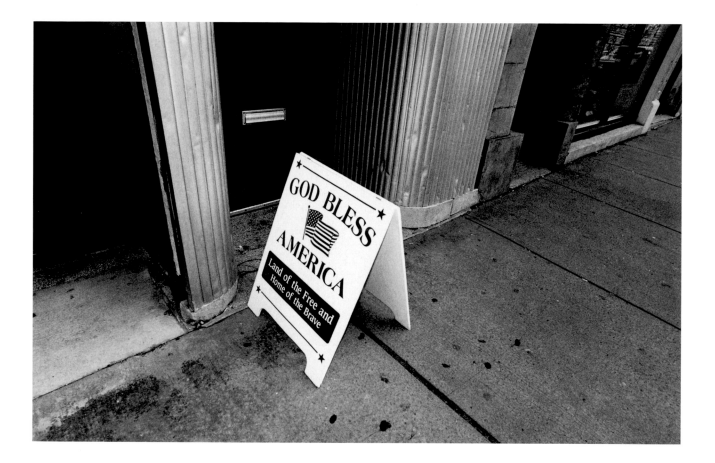

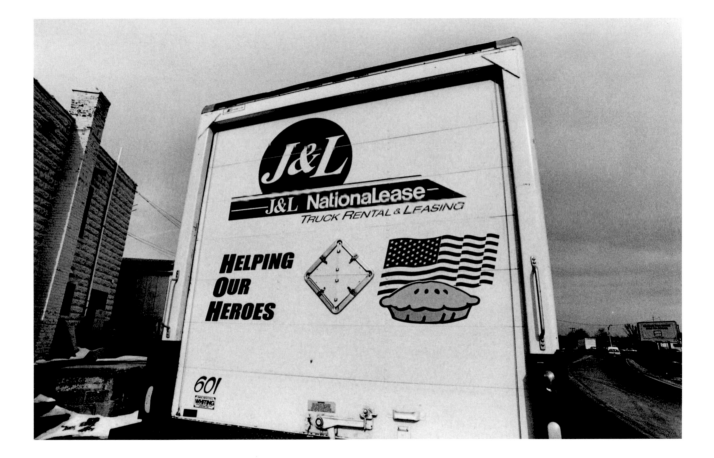

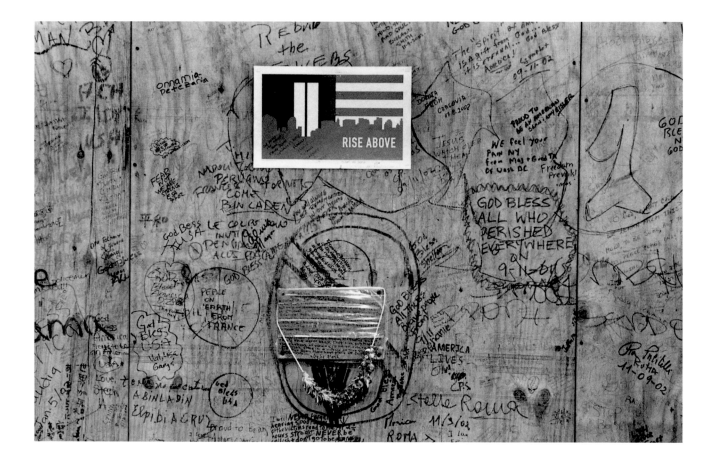

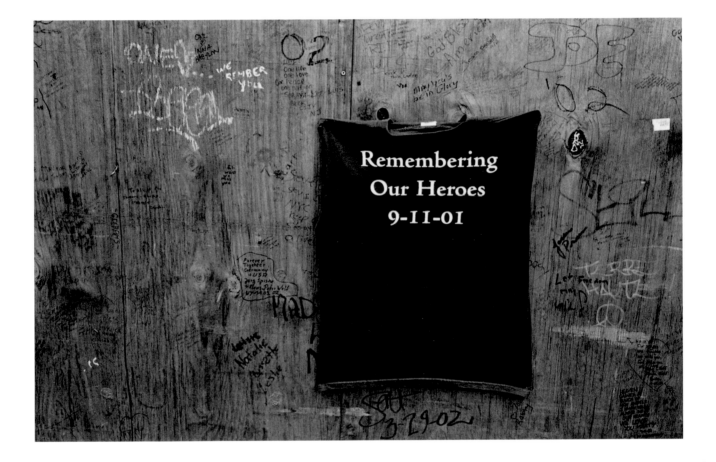

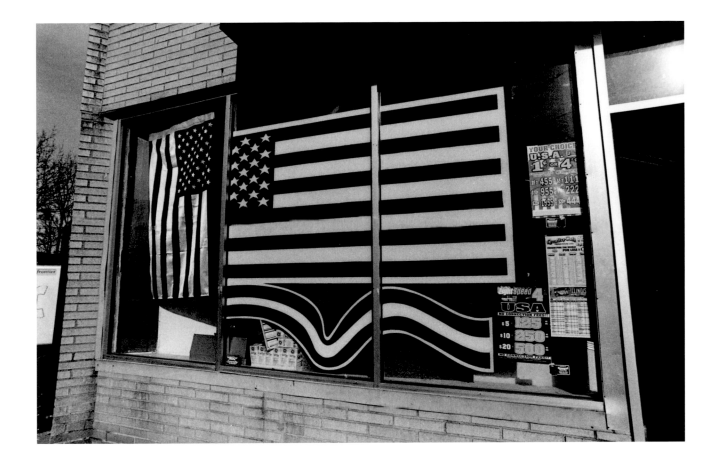

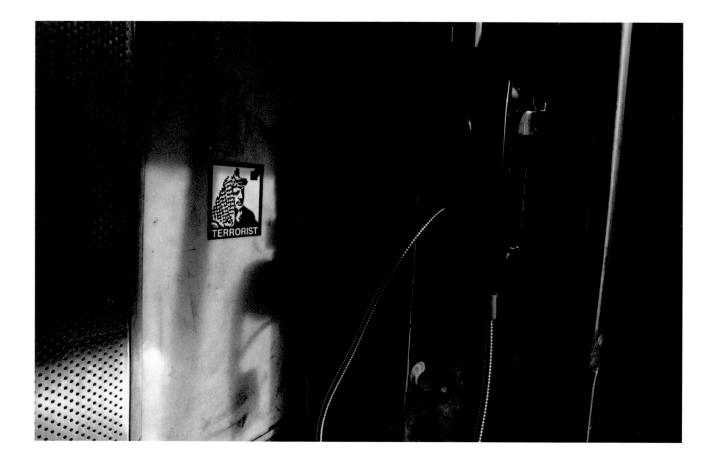

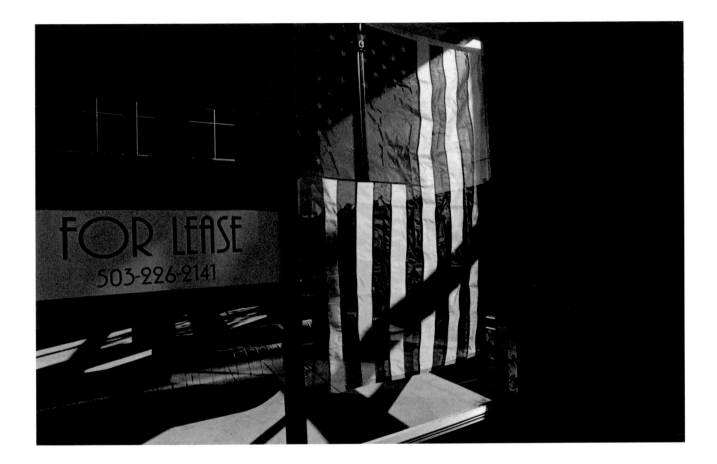

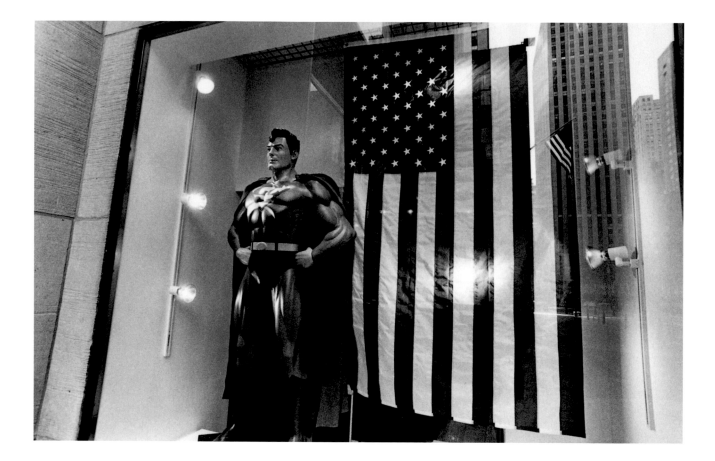

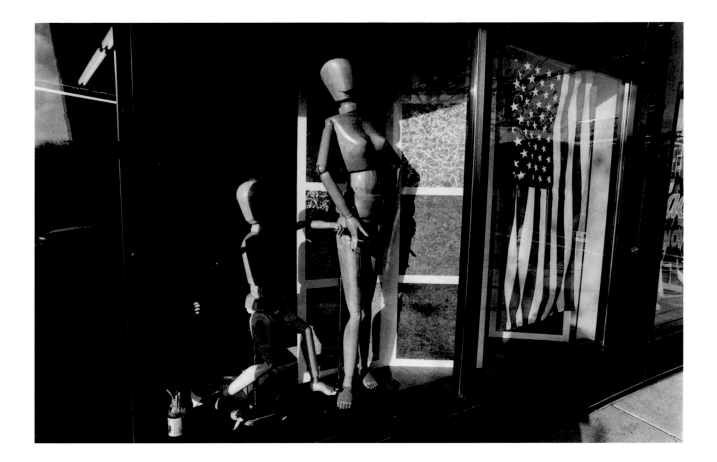

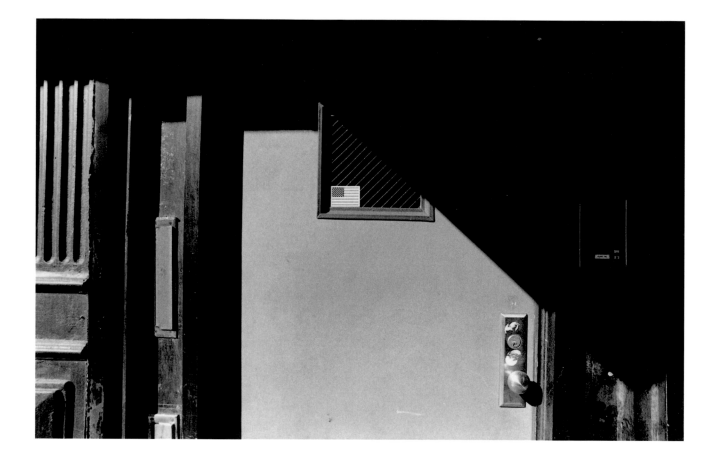

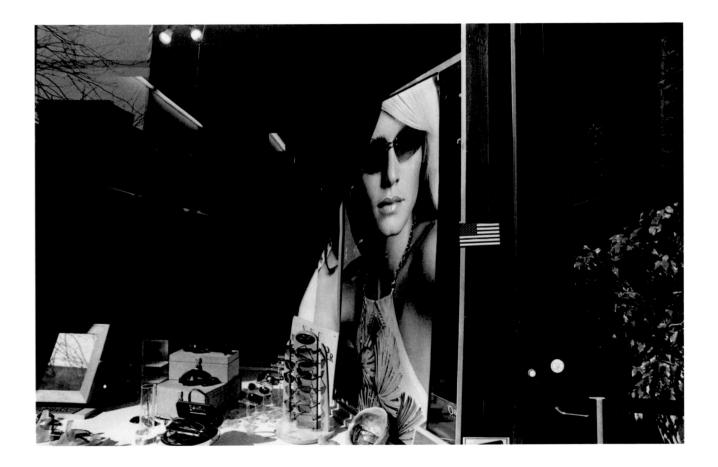

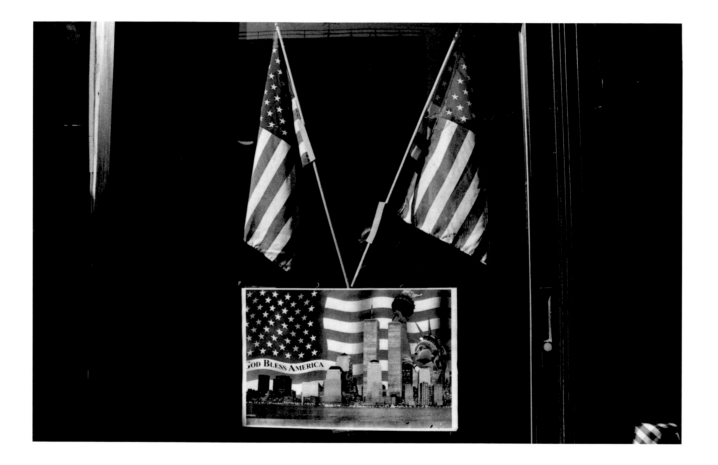

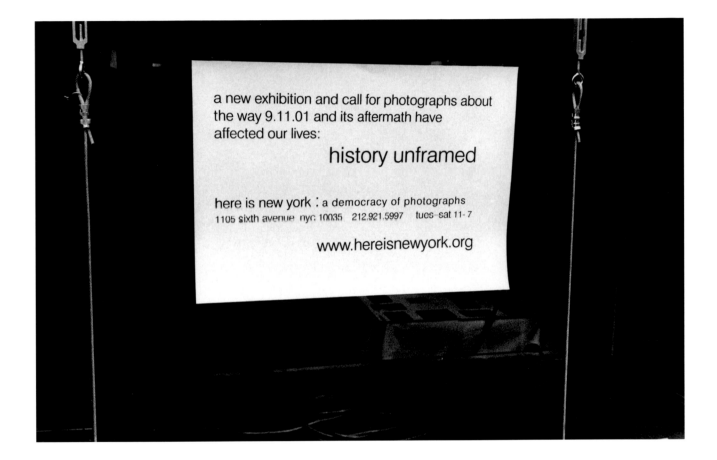

a new exhibition and call for photographs about
the way 9.11.01 and its aftermath have
affected our lives:

history unframed

here is new york : a democracy of photographs
1105 sixth avenue nyc 10035 212.921.5997 tues–sat 11–7

www.hereisnewyork.org

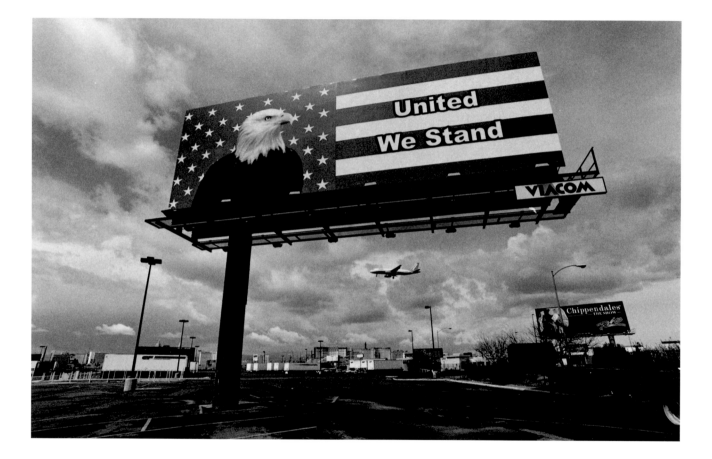

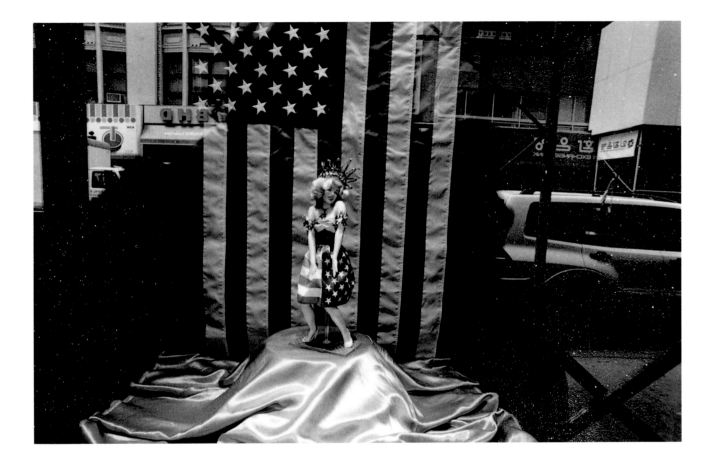

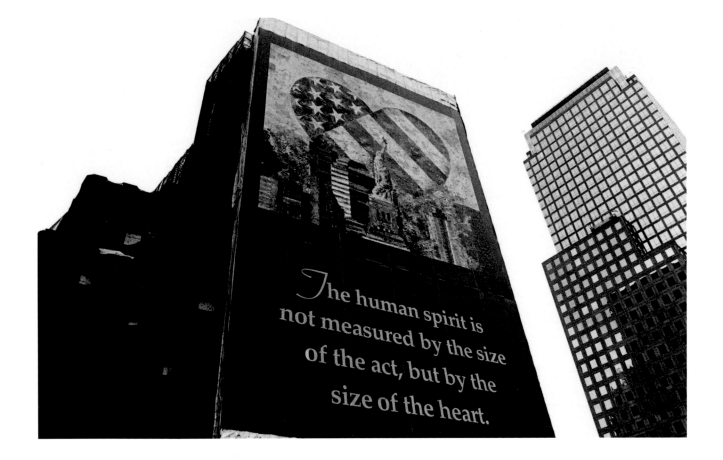

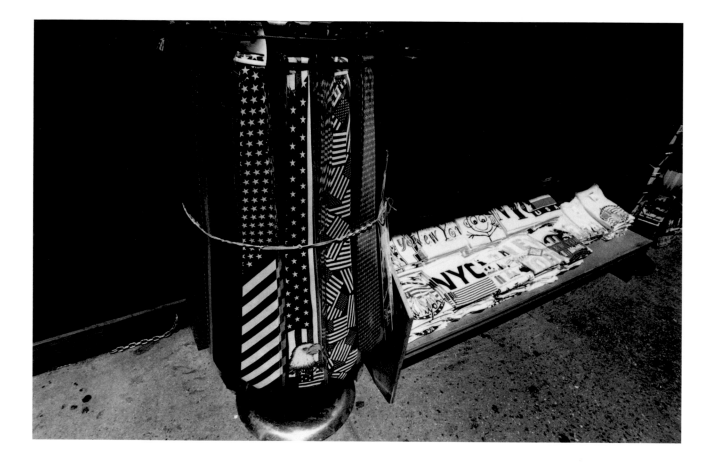

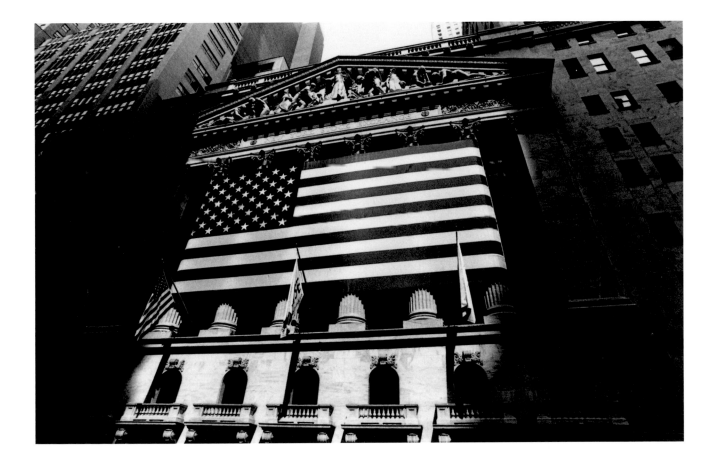

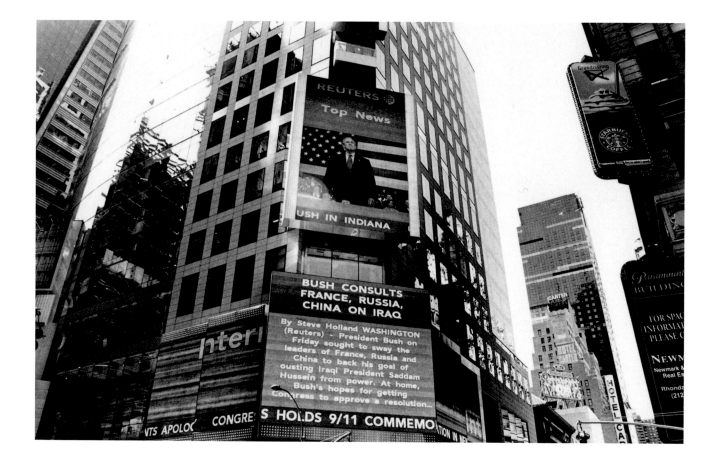

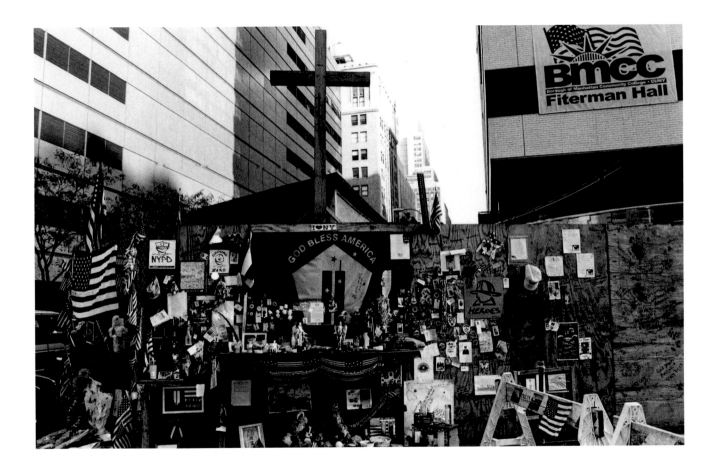

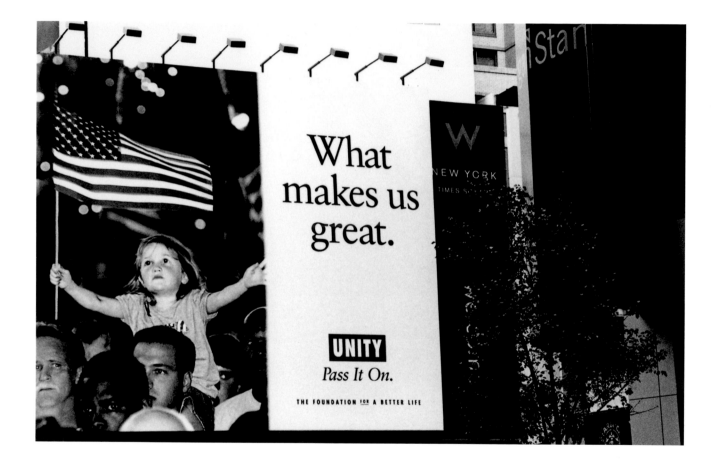

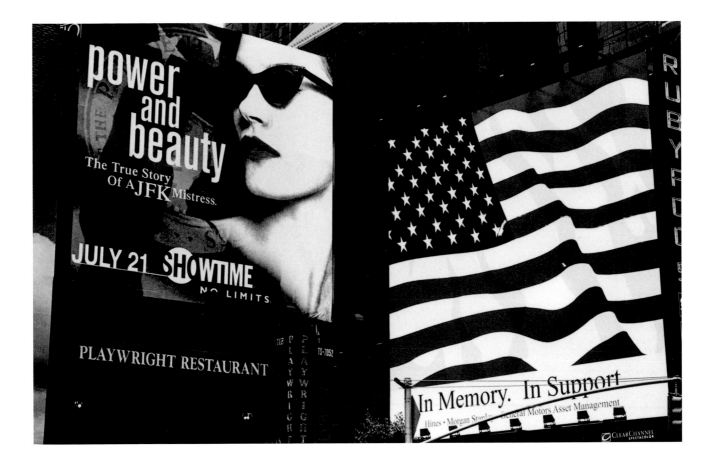

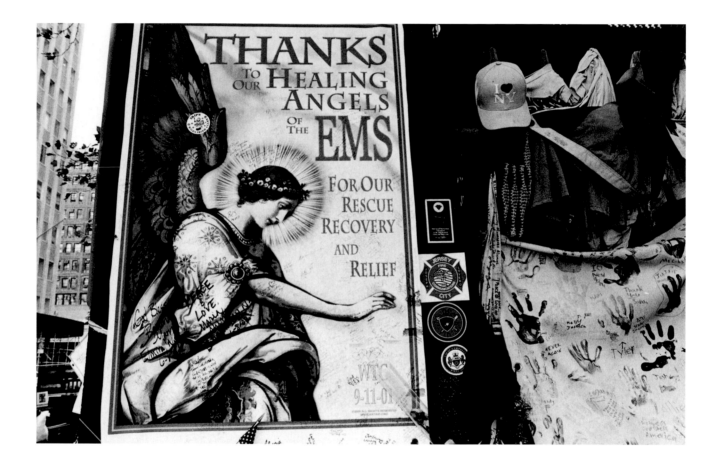

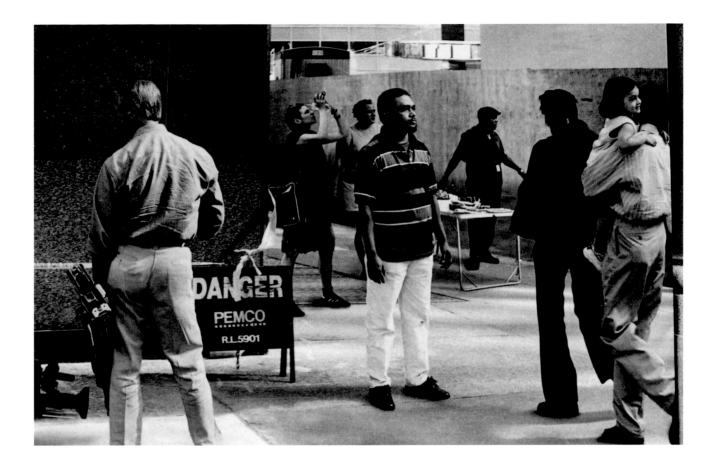

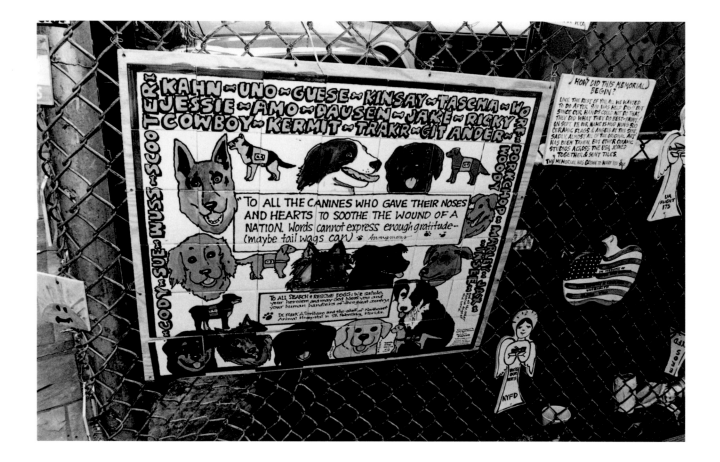

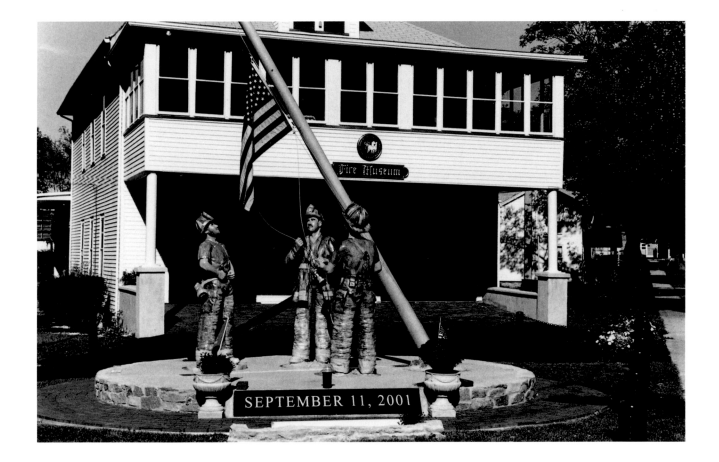

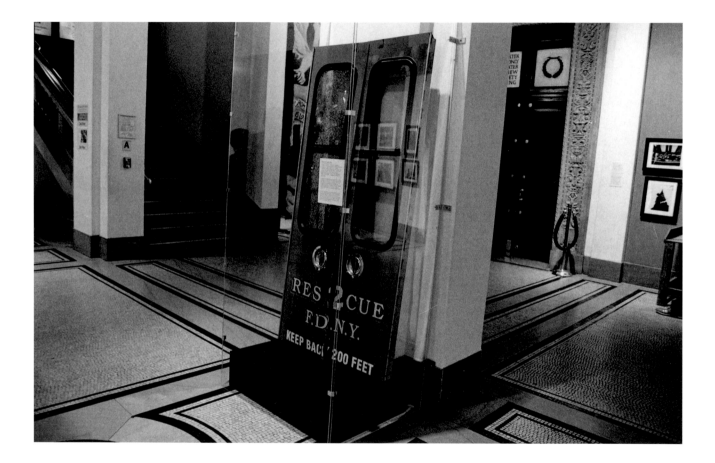

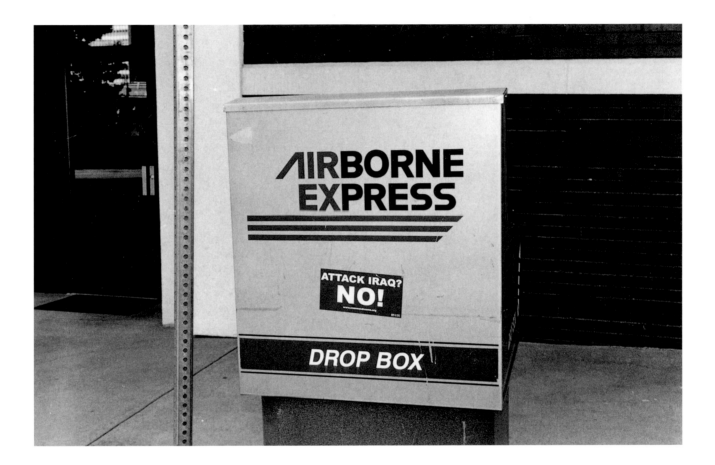

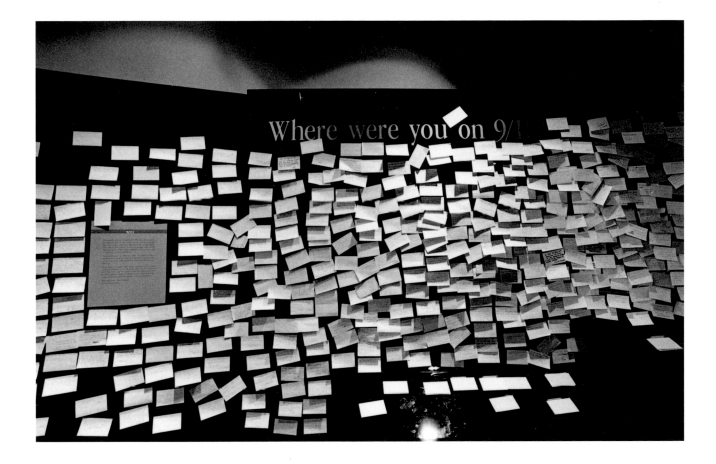

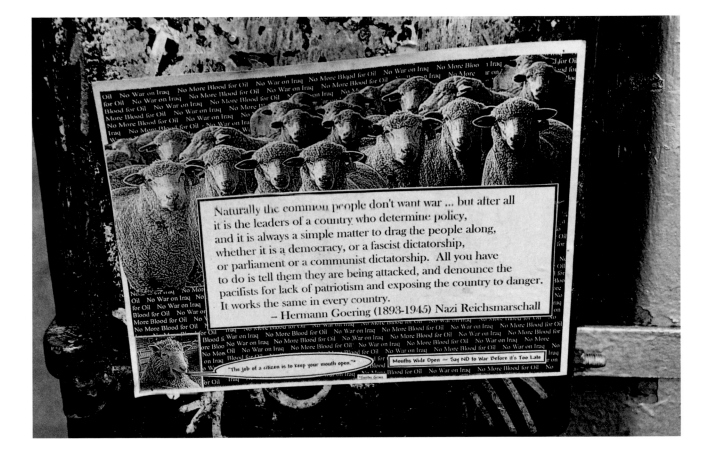

Richard Benson

At first glance the book seems to be full of flags, but, of course, they are really only pictures. If we went out into Nathan's world, the very one he walked through to make these photographs, we would find that most of the flags themselves weren't real, but instead were second-, third-, or even fourth-generation images of flags. A genuine flag, of soft, light, and colored bunting, high on a staff and rippled by the wind, is a delicate object, yet one of such immense power that even as a distant copy it retains its ability to move us. What is this potent symbol, and how did it come to be?

Flags began in China, originating as military standards to identify tribal groups in parade and battle. They probably started as sculptural symbols, held atop vertical shafts, but these evolved into cloth banners of varied shapes and sizes. Moving out of Asia to the west, the flag reached its modern form in the countries of Islam, and traveled from there to Europe, and then across the big pond to the colonies in North America. Muslim flags tended to be of a solid color such as black, yellow, red, or green,

adhering to a religious prohibition of pictures and symbols. Eventually imagery crept in, until the crescent moon became the norm for the battle flags of Islam. We should not be surprised that the all-powerful flag, able to stir our patriotism in even the worst of times, should come from those with whom we now have differences. The apparent conflict between Christianity and Islam, two great mono-theistic religions, is but a temporary thing, fomented by illness within both ranks, and bound to pass, like some unavoidable adolescent stage.

France gave our flag its colors; the revolutionary red, white, and blue were adopted for its tricolor. England donated the union—that quarter of the banner that is in the upper corner, next to the staff. Flags held such power that they could be used to bring diverse people together, and even groups as different as the English, Scots, and Irish could march together under the fragile cloth, as long as their union was adequately represented in the banner's design. In Old Glory the union is the blue patch, holding the stars, and each star represents a state. Over the years our flag has had a changing union,

to accommodate new stars as America grew. When the United States was young the flag makers even added a new stripe of red or white as each successive state was added, but soon the flag design became weak, and, even worse, looked pink at a distance when there were too many fine stripes. As it is now, thirteen red and white lines mark the original thirteen states, but, even more importantly, they make an irresistible representation of the redness of blood flowing on the white field of honor. We must never forget that this symbol of America is firmly and irretrievably imbedded in military history, and the pacifist within us would do well to stare this fact squarely in the face.

Flags have been called by many names—banners, ensigns, standards—but the common present name has two probable roots. One is the Scandinavian *flagge*, to flutter in the wind, which evokes the ideal flag—held high, resisting the elements, uniting its followers, and presenting ephemeral delicacy that has a strength beyond its material being. The other root is not so comforting, but just as accurate—*flacken*—Middle English for drooping or hanging loose. We take flags in at night, because when the sun-bred breezes of the day die away, the flags hang limp and still, and the symbolism too accurately portrays the other side of militaristic life—the stillness, weariness, and finality of conflict's other side, off the field, after the mad rush of irrationality that sends so many soldiers to their end.

The wounded bird, ere yet she breathed her last,
With flagging wings alighted on the mast.
 Pope, Iliad, xxiii

Nathan has given us a parade of flags—in print, plastic, cloth, and paint—and he shows them as ubiquitous markers of our national pride and consciousness. The miracle of America is in the diversity that the flag so boldly encompasses—it turns our many tribes into one and carries us through the ups and downs of toil and tears. The original flag—spawned in war and revolution—has become our embracing shroud of grief and pride.

national chairman. By 1969, with a torrent of creative projects and ideas in full play, he took the biggest risk of his young career and left the George Eastman House to found and direct the Photographic Studies Workshop, which became known during the 1970s as the Visual Studies Workshop (VSW). Under Nathan's leadership and that of his devoted wife and partner, Joan Lyons, the artists' organization blossomed to become a leading educational and presenting forum for the training and support of hundreds of artists, curators, writers, media specialists, and teachers. A remarkable number of these individuals now hold important positions of creative influence and leadership in American and international visual culture. Today, the Visual Studies Workshop's ground-breaking journal *Afterimage*, also founded by Nathan as its first editor in 1972, as well as its gallery, print shop, editing and artist-in-residence facilities, and research center (a repository of more than eight hundred thousand images, a library of fifteen thousand volumes, and an artist book collection of some four thousand titles), all remain as remarkable resources for those interested in the active production and study of visual culture across the media of photography, film, video, and visual books.

Nathan has created his own photographs and pursued his career as a artist/teacher/director during an historical era when still, film, and television cameras began to deluge humankind with images of all kinds—presented in countless controlled and intended contexts and also myriad chance juxtapositions. He was among the first artists of his generation to understand the need to train young people to become critically literate as to what they were seeing in an image-laden world, and to understand not only the specific content and form of any specific photographic image they might behold, but also something about the human motivations and purposes that brought it into being. Be they family snapshots, commercial advertise-ments, political propaganda, scientific studies, or artistic ventures, Nathan has consistently professed that since photographic images receive constant scrutiny, they also deserve critical attention. He has spent most of his life—in innumerable ways—deconstructing, interpreting, and amplifying images for others as both an educator and an artist. As a

world citizen, his efforts to create a photographic community have been continuously expansive. In 1983, for example, Nathan initiated the Oracle conference, now a major annual meeting of curators and directors of photographic institutions that migrates around the globe.

Nathan has also received numerous artistic and service awards for his long list of creative accomplishments and public service, notably a Senior Visual Artist Fellowship from the National Endowment for the Arts (1985), an honorary doctorate from the Corcoran School of Art in Washington, D.C. (1995), the Infinity Award for Lifetime Achievement from the International Center of Photography (2000), and most recently, the title of Distinguished Professor Emeritus at SUNY Brockport, the campus now closely affiliated with the Visual Studies Workshop in Rochester.

Here at Yale University, where Dean Richard Benson and his School of Art faculty, as well as the Art Gallery's staff, train some of America's finest young photographers and also engage many undergraduate students in the medium of photography as practitioners and viewers, Nathan's work as an artist and educator has long been appreciated. Throughout these last two years, as many image makers—both young and old—have sought to somehow document and/or interpret the tragic events of September 11, 2001, Nathan's work with his camera and at his editing table has stood out as a beacon of clear seeing and thinking. Of course, none of us now can fully anticipate which images related to this tragic day may in time come to best memorialize the tumultuous and highly emotional human responses to this momentous event and the enduring effect it will exert on our country, its citizens, and the world at large. That said, we're certainly willing to wager that this particular sequence of photographs will eventually take its place as a definitive artistic contribution to the American experience writ large.

The Yale University Art Gallery is grateful to have acquired this body of photographs for its permanent collection and to have produced this artist book in close partnership with Nathan Lyons and the Yale University Press. The very kind generosity and patronage of Timothy Bradley '83 and Eliot Nolen '84, Susan and Arthur Fleischer Jr. '53, '58 Law, Carolyn and Gerald Grinstein '54, Betsy and Frank Karel and the Mr. and Mrs. George Rowland, B.A. 1933, Fund have made this possible.

To Ella and Wes

Grateful acknowledgment is expressed
to Marvin Bell, Karmen Polydorou, Joan Lyons,
Jock Reynolds, Richard Benson, Patricia Fidler,
Lesley Tucker, Yale University Art Gallery,
and Yale University Press for their help in
realizing this project. I sincerely hope that
I've left a sequence of photographs that will
continue to engage people to question the
aftermath of 9/11 and never to forget the tragic
loss of so many innocent lives.

A traveling exhibition of "After 9/11" is available from:
Spectrum Gallery, 439 Monroe Avenue
Rochester, New York 14607

The exhibition is available for preview
at www.spectrumgallery.com
For further information,
please contact William Edwards, Director
Tel. #: 585.461.4447 or info@spectrumgallery.com

A portfolio of fifteen prints from the 9/11 project
is available through either Spectrum Gallery in
Rochester, NY or the Howard Greenberg Gallery
in New York, NY.

Exhibition Schedule

Light Work, Syracuse, New York
August 20–October 15, 2003

Firehouse Art Gallery, Nassau Community
College, Garden City, New York
Vexillology: The American Symbol in Art
Selected photographs from *After 9/11*
September 2–October 1, 2003
Opening reception and lecture
September 11, 2003

Centro Nacional de las Artes, Sponsored
by Centro de la Imagen, Mexico City, Mexico
September 18–October 26, 2003

ACTA International, Rome, Italy
Selected Photographs from "After 9/11"
November 26–December 18, 2003

© 2003 Yale University Art Gallery
P.O. Box 208271, New Haven, CT 06520-8271

All photographs © Nathan Lyons
"Flags Cleaned Free" © Marvin Bell

Published by Yale University Art Gallery
Distributed by Yale University Press

ISBN 0-300-10182-1
Library of Congress Control Number: 2003106780

Printed by Meridian Printing
East Greenwich, RI
on 100-lb. Chorus Art Silk
Bound by Acme

Sequence: Nathan Lyons
Design: Lesley Tucker
Printing Supervision: Daniel Frank